PAINTER'S QUICK REFERENCE

Santas & Snowmen

EDITORS OF NORTH LIGHT BOOKS

NORTH LIGHT BOOKS

CINCINNATI, OHIO

www.artistsnetwork.com

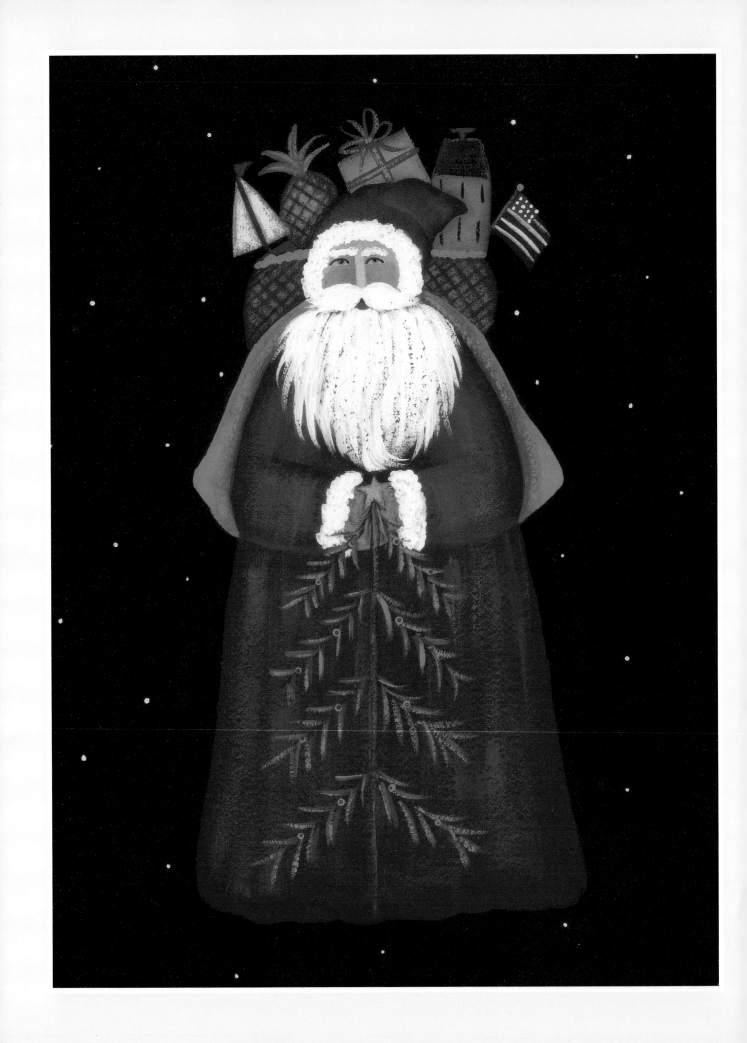

PAINTER'S QUICK REFERENCE

Santas & Snowmen

EDITORS OF NORTH LIGHT BOOKS

NORTH LIGHT BOOKS
CINCINNATI, OHIO
www.artistsnetwork.com

Published by North Light Books, an imprint of F+W Publications, Inc., 4700 East Galbraith Road, Cincinnati, Ohio 45236. (800) 289-0963. First edition.

Other fine North Light Books are available from your local bookstore or art supply store, or direct from the publisher.

09 08 07 06 05 5 4 3 2 1

Library of Congress Cataloging-in-Publication Data
Santas & snowmen / editors of North Light Books.
 p. cm. -- (Painter's quick reference)
 ISBN 1-58180-614-0 (pbk: alk. paper)
 ISBN 1-58180-616-7 (alk. paper)
 1. Santa Claus--Art. 2. Snowmen in art. 3. Painting--Technique.
I. Title: Santas and snowmen. II. North Light Books (Firm) III. Series.

ND1460.S25S26 2005
758'.93942663--dc22
2004059508

fw
F+W PUBLICATIONS, INC.

Editors: Christina D. Read & Kathy Kipp
Series Designer: Karla Baker
Art Director: Camille DeRhodes
Layout Artist: Amy F. Wilkin
Production Coordinator: Kristen Heller
Photographer: Tim Grondin

Metric Conversion Chart

to convert	to	multiply
Inches	Centimeters	2.54
Centimeters	Inches	0.4
Feet	Centimeters	30.5
Centimeters	Feet	0.03
Yards	Meters	0.9
Meters	Yards	1.1
Sq. Inches	Sq. Centimeters	6.45
Sq. Centimeters	Sq. Inches	0.16
Sq. Feet	Sq. Meters	0.09
Sq. Meters	Sq. Feet	10.8
Sq. Yards	Sq. Meters	0.8
Sq. Meters	Sq. Yards	1.2
Pounds	Kilograms	0.45
Kilograms	Pounds	2.2
Ounces	Grams	28.3
Grams	Ounces	0.035

Introduction

WHEN YOU'RE IN A HURRY FOR PAINTING HELP, HERE'S THE BOOK TO COME TO FOR IDEAS, INSTRUCTIONS AND INSPIRATION.

There's nothing more fun than painting holiday projects and gifts. We want to inspire you this holiday season! This book is full of Santas and snowmen—favorite holiday symbols. And they are all painted in a variety of styles. You'll find folk art, whimsical, "realistic" and just plain jolly Santas and snowpeople. The artists have included "close-ups" or details of different elements in their paintings. All to give you fresh ideas and spark your painting creativity.

So, choose your favorites or try a completely new painting style! Combine elements from different projects. We hope you enjoy painting your holiday treasures!

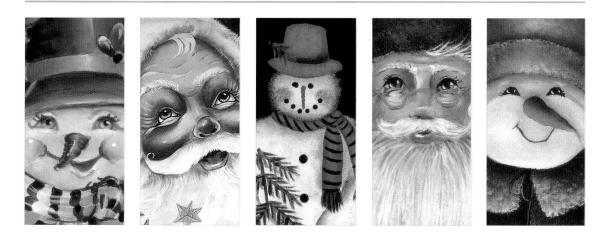

Table of Contents

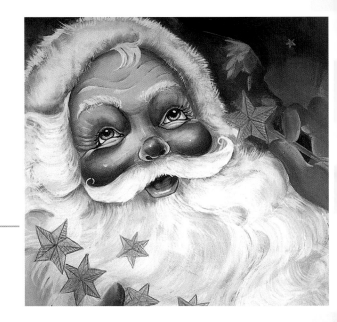

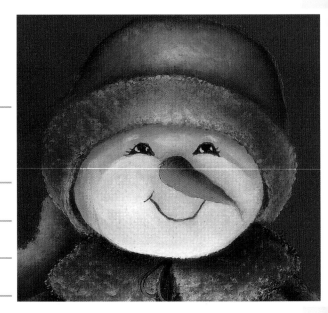

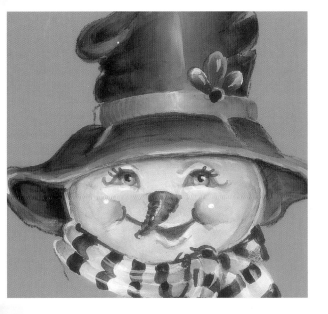
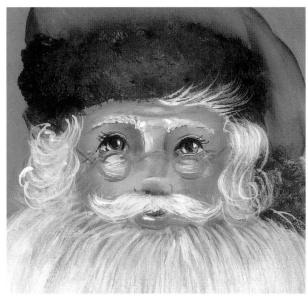

CHAPTER **1**
Painting Santa

There's nothing like painting that jolly old elf himself, Santa Claus, to add the perfect spirit of Christmas to your artwork. In this chapter, you'll find Santa painted in a variety of styles. You'll also find step-by-step directions on those special elements—Santa's eyes, beard and furry hat. So you can pick and choose what you need to make your Santa unique!

Any of these Santas can be painted on your choice of surface. Pick up that brush and paint some holiday cheer!

"Christmas Delivery"
PAM GRADY

MEDIUM: *Acrylic*

COLORS: **DecoArt Americana:** *Flesh Tone • Shading Flesh • Neutral Grey • Antique White • Celery Green • Red Iron Oxide • Light Buttermilk*

BRUSHES: **Loew-Cornell:** *¼-inch (6mm) angular • no. 10/0 liner • no. 1 liner*

OTHER SUPPLIES: *black Pigma Micron .05 pen*

SANTA'S FACE

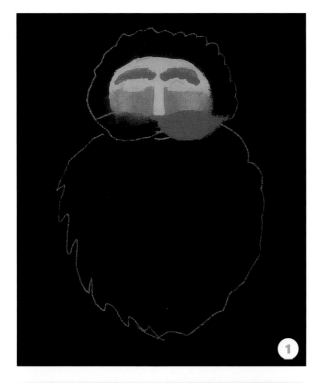

1 Face, Eyebrows & Mustache

After basecoating the face with Flesh Tone, use a
¼-inch (6mm) angular brush and Shading Flesh to float
on each side of the nose. Repeat this step several times,
walking out the float to the cheek area. Mustache and
eyebrows are basecoated with Neutral Gray.

2 Eyes, Lips & Mustache

Using a no. 10/0 liner brush, fill in the eye area using
Antique White. Dot irises with a stylus and Celery
Green. Use a no. 10/0 liner and Red Iron Oxide for
lips. To make eyelids, use a Black Pigma Micron .05 pen.
Fill in mustache using Light Buttermilk.

3 Final Details

Pupils are made using a Black Pigma Micron .05 pen.
Load a no. 10/0 liner heavily with Light Buttermilk
for stroke work on mustache and beard. Dab Light
Buttermilk on fur area using a no. 1 liner.

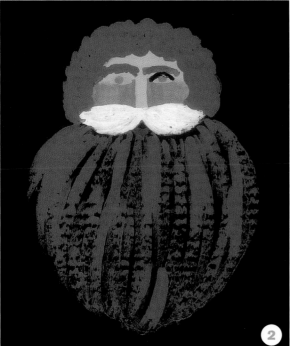

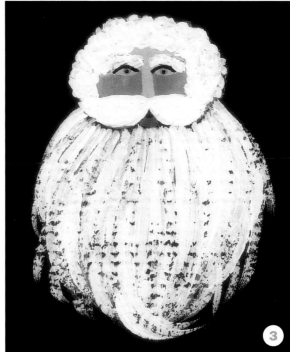

"Painting Realistic Santa Eyes"

MARY ANN SPAINHOUR

MEDIUM: *Acrylic*

COLORS: **DecoArt Americana:** *Shading Flesh • Winter Blue • Hi-Lite Flesh • Burnt Sienna • White • Black • Graphite • Medium Grey • DeLane's Cheek Color • Emperor's Gold (Metallic) • Burnt Umber*

BRUSHES: **Schraff:** *no. 10/0 liner • no. 4 flat • no. 6 flat • no. 12 flat*

OTHER SUPPLIES: *grey graphite paper*

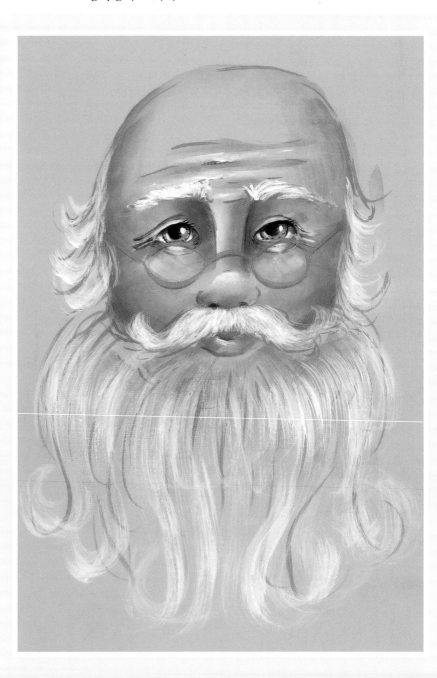

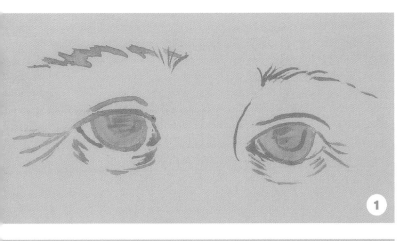

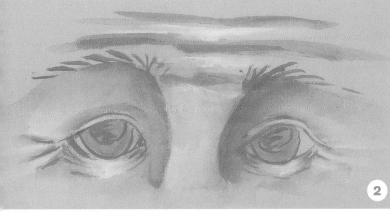

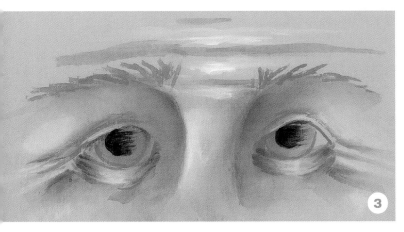

1 Transfer the Basic Features
Transfer the basic features with old grey graphite paper. Detail with a no. 10/0 liner using thin Shading Flesh. Use the tip of the brush, keeping it at a 90° angle. Paint the iris of the eye with a wash of Winter Blue.

2 Shading, Highlighting, Painting Brows
Shade the areas of the face that recede with a no. 12 flat side loaded with Shading Flesh. Chisel in the brow wrinkles and creases around the eyes. Highlight the areas that protrude with a no. 6 flat side loaded with Hi-Lite Flesh.

3 Pupil & Iris
Deepen the first shade with Shading Flesh and Burnt Sienna (1:1). Lighten the first highlight with Hi-Lite Flesh and White (1:1). Paint the pupil with a no. 4 flat side loaded with Black. This is a "C" stroke. Stand the brush on the chisel to pull Black softly out into the iris.

Painting Realistic Santa Eyes

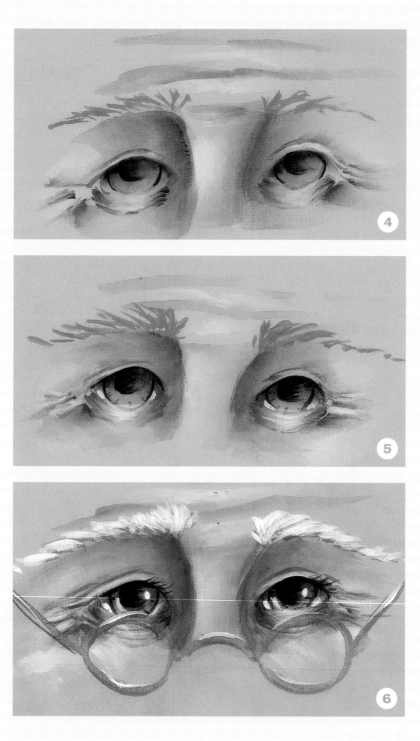

4 Eye Line and Shading

To push the eye under the lid, load a no. 4 flat with thin Graphite and shade across the top of the eye area. Use a no. 10/0 liner loaded with thin Black to paint the eye line and the lines on each side of the iris. Deepen the shade around the eyes with Burnt Sienna.

5 Eyebrows and Creases

Paint the eyebrows with Medium Grey using the no. 10/0 liner. Touch Hi-Lite Flesh into the whites of the eye. Touch DeLane's Cheek Color into the inside corners of the eye. Lighten the bags under the eye and in the creases with Hi-Lite Flesh and White.

6 Finish Eyes & Paint Glasses

Finish the eyes with White highlights. A touch of lash is painted with the no. 10/0 liner using Black. To deepen the shade next to the nose, use thin Burnt Umber on a no. 12 flat. Paint the eyebrows with White.

The glasses are Emperor's Gold painted with a no. 10/0 liner, underlined with Burnt Umber and highlighted with White. Brush a touch of White into the glass area.

"Simply Santa"

PEGGY JESSEE

MEDIUM: *Acrylic*

COLORS: **Delta Ceramcoat:** *White • Mendocino Red • Quaker Grey • Storm Grey • Medium Flesh • Adobe Red • Burnt Sienna • Black • Midnight Blue • Black Cherry • Pine Green • Medium Foliage Green*

BRUSHES: **Loew-Cornell:** *deerfoot brush • large filbert rake • ¼-inch (6mm) or ⅜-inch (10mm) angle brush • no. 4 or no. 6 filbert*

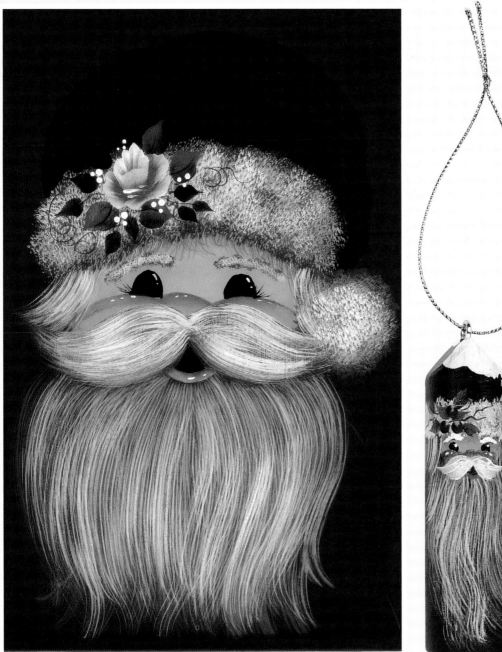

Simply Santa

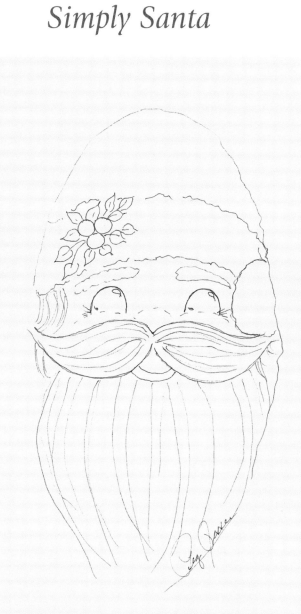

1 Line Drawing

This line drawing may be hand-traced or photocopied for personal use only. Enlarge at 188% to bring it up to full size.

2 Basecoating

Basecoat the hat with Mendocino Red. Shade and float in the folds with Midnight Blue. Basecoat the face with Medium Flesh. The fur trim and streaks in the beard are painted with Storm Grey.

3 Layering Colors
Shade the hair line with Burnt Sienna. Float cheeks with Adobe Red. Basecoat the mustache with Storm Grey.

Colors for the beard and fur are applied in the following order: Storm Grey, Quaker Grey, Quaker Grey and White, then White. Use a deerfoot brush to paint the fur. The brush should be soft and spread out. Use a dry brush so that the paint stays thick.

TAKE NOTE

Feel free to change the colors. Pick your favorite red—maybe you like a dull country red or maybe a bright red. I have even used Midnight Blue or Pine Green to paint the hat. The key is to paint with colors you like and to have a good time!

4 Layering More Colors
Basecoat the eyes with Black and highlight with White. The mouth is Mendocino Red and the lower lip is Medium Flesh.

Fur is pounced on with a deerfoot brush, working the colors from dark to light. Allow the colors to dry partially between layers of color.

The beard is painted with a large filbert rake brush, again applying colors from dark to light. To use the filbert rake, make sure your paint is the proper consistency. It needs to be thin enough to come off the brush easily but still have enough body to hold the strokes without losing shape on the beard.

Simply Santa

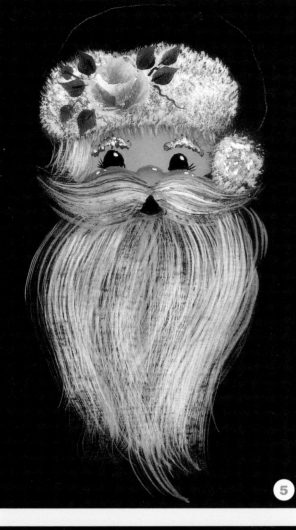

5 Finishing Details

Place sparkle dots on the cheeks with White.

Shade the mouth with Black. The bottom lip is shaded with Burnt Sienna.

Float a very scant amount of Midnight Blue on the beard under the mustache for shading.

Add the stroke roses and leaves, if you wish. (See next step.)

6 Stroke Roses and Leaves

Roses are painted with an angle brush and leaves are painted with a filbert. A great way to practice these is to place a sheet of transparency film over the roses and practice the strokes. This will help you develop a feel for the shape of the strokes.

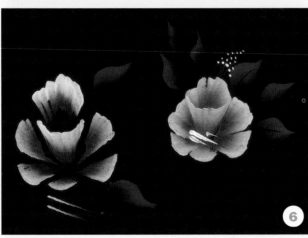

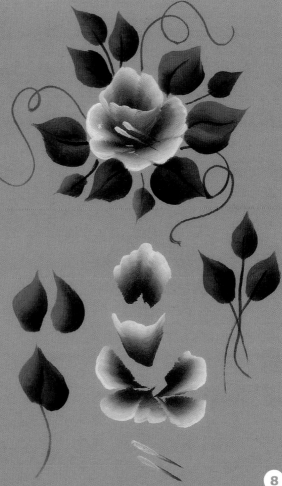

7 Step-by-Steps for Painting Roses

Use an angular brush double loaded with the dark color (Black Cherry) on the short angle and the light color (White) on the long angle of the brush for all strokes.

The first two strokes are double-loaded "C" strokes, one up and one down. Connect the light edge to the light edge.

The next four strokes are pivot strokes—place the brush on the surface, hold the short angle of the brush as stationary as possible and swing the long angle to make a petal. The petals are two on the right side of the bowl, then reverse and do two on the left.

Stroke 7 is a small filler stroke—approximately one-quarter circle—to tie the bottom petals together.

Stroke 8 is just slashes using the long angle of the brush, loaded with light color, to fill in beneath the rose bowl.

If you wish to add more petals to your rose, add smaller pivot strokes so that they are inside the outer petals. Make sure to stagger the petals so that they do not overlap perfectly.

8 Stroke Leaves

Paint simple one- or two-stroke leaves, using a filbert brush. Vary brush sizes to vary leaf sizes. Use complimentary green shades (in this example, Pine Green and Medium Foliage Green), both single loaded and double loaded.

Small filbert brush-stroke flowers of four or five petals or tiny petals done with a liner brush make great filler for your designs.

"Santa's Beard"

MARY ANN SPAINHOUR

MEDIUM: *Acrylic*

COLORS: ***DecoArt Americana:*** *Shading Flesh • Graphite • Titanium (Snow) White • DeLane's Cheek Color • Medium Grey*

BRUSHES: ***Schraff:*** *no. 10/0 liner • no. 12 flat* ***Royal:*** *¼-inch (6mm) filbert rake or comb*

OTHER SUPPLIES: *white graphite paper*

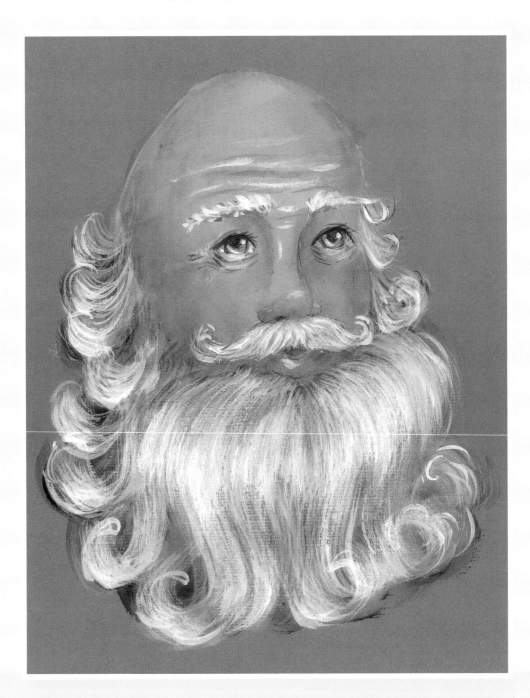

1 Transfer the Features

Transfer the features from the finished drawing on page 18 with white graphite paper. Detail the transferred lines with a no. 10/0 liner loaded with thin Shading Flesh. Softly wash in the shape of the beard with a no. 12 flat side loaded with Graphite.

2 Beard

Paint the beard with a ¼-inch (6mm) filbert rake or comb. Load the brush with thin Medium Grey. Keep the brush at a 90° angle to the surface, using only the tip of the brush. Follow the flow of the beard.

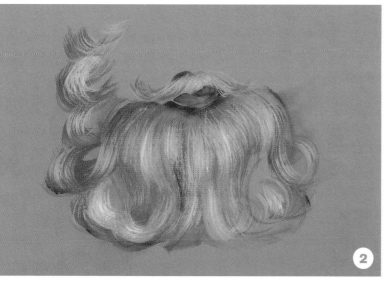

3 Lighten the Beard

Paint Santa's lips with DeLane's Cheek Color. Lighten the beard with Titanium (Snow) White. Leave dark areas in the beard. Light areas protrude and darker areas recede. Finish the ends of the beard and mustache using the no. 10/0 liner loaded with thin Titanium (Snow) White paint.

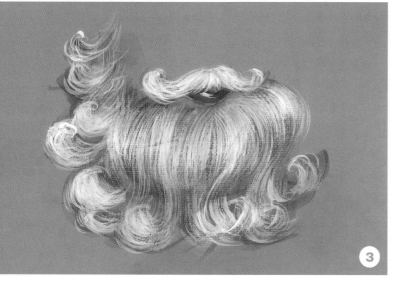

"Folk Art Santa"

PEGGY JESSEE

MEDIUM: *Acrylic*

COLORS: **DecoArt Americana:** *Rookwood Red • Antique Maroon • Antique Gold • Yellow Ochre • Light Parchment • Buttermilk • Light Buttermilk • Titanium (Snow) White • Medium Flesh • Delane's Dark Flesh • Asphaltum • Burnt Umber • Lamp (Ebony) Black*

BRUSHES: **Loew-Cornell:** *no. 2 liner • angular shader • filbert (brush size depends on the size you choose to paint your Santa)*

OTHER SUPPLIES: *Minwax Early American stain*

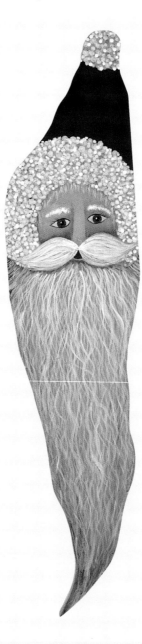

1 Line Drawing

This line drawing may be hand-traced or photocopied for personal use only. Enlarge at 178% to bring it up to full size.

2 Basecoating

Basecoat the hat with Rookwood Red, the face with Medium Flesh and the beard, mustache and hat trim with Yellow Ochre.

Folk Art Santa

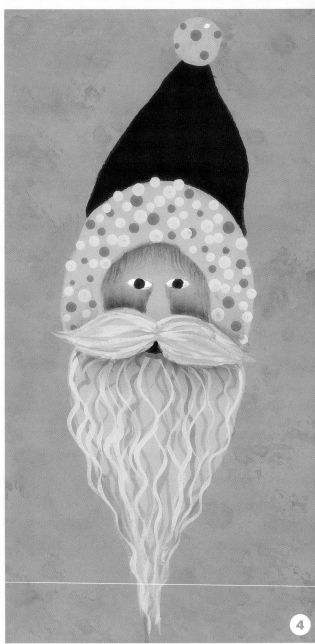

3 Add Details

Trace the facial features and basecoat the eyes with Titanium (Snow) White. Shade the hat with Antique Maroon.

The trim on the hat is done with lots of dots. Use the end of the brush handle, dip into paint and make three or four dots. Reload the brush handle end with one color at a time and allow to dry between colors. Apply colors as follows: Antique Gold, Light Parchment, Buttermilk, Light Buttermilk and Titanium (Snow) White.

Using a no. 2 liner, start making wiggly lines starting under the mustache and pulling toward the bottom of the beard.

4 Hair, Eyes, Nose & Mouth

Pull hair around the face with Asphaltum. Base the iris with Burnt Umber. The pupil is Lamp (Ebony) Black, outlined with Burnt Umber. The dots in the eyes are Titanium (Snow) White.

Float down the side of the nose and across the cheeks with Rookwood Red. Basecoat the mouth with Rookwood Red; shade the top of the mouth with Lamp (Ebony) Black. Basecoat the lower lip with Medium Flesh; shade with DeLane's Dark Flesh.

On the mustache, pull lines from the center to the outer edge. Layer colors in the same order as the dots on the hat.

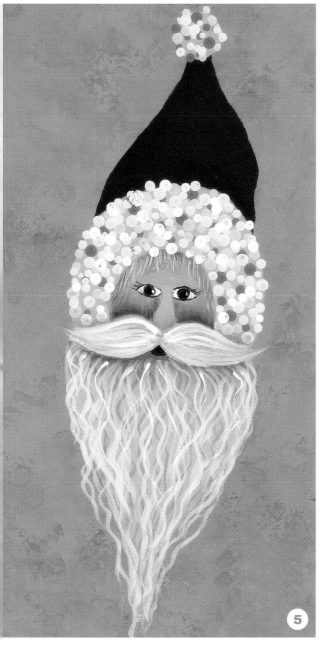

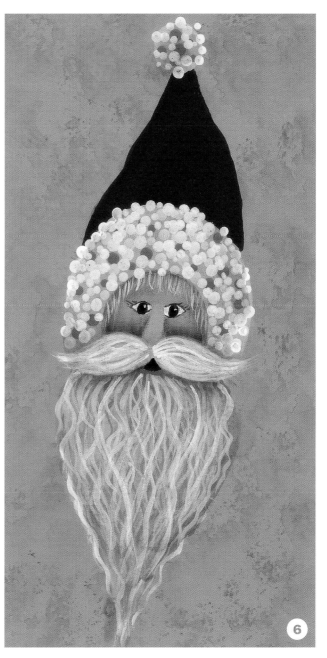

5 More Dots & Line Work

Continue layers of dots and line work for beard and hair using lighter colors.

6 Antiquing

Antique using Minwax Early American stain. Allow to dry. To brighten Santa, add a little more hair and a few more dots, using Titanium (Snow) White.

"Santa on a Dictionary Cone"

MARY ANN SPAINHOUR

MEDIUM: *Acrylic*

COLORS: **DecoArt Americana:** *Flesh Tone • Shading Flesh • Hi-Lite Flesh • Desert Turquoise • Titanium (Snow) White • Lamp (Ebony) Black • Burnt Umber • Burnt Sienna • DeLane's Cheek Color • Emperor's Gold (Metallic)*

BRUSHES: **Schraff:** *no. 10/0 liner • no. 6 flat • scruffy brush*
Royal: *¼-inch (6mm) filbert rake or comb*

OTHER SUPPLIES: *spray varnish • dictionary cone (see Resources)*

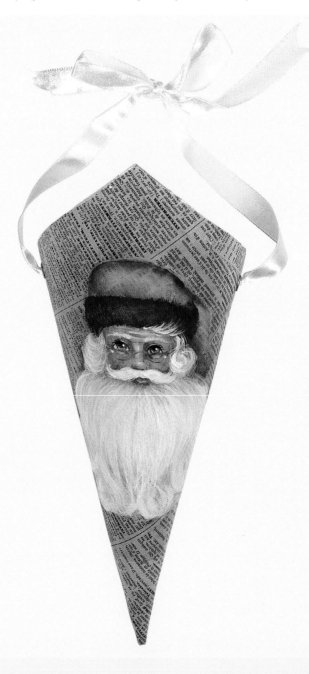

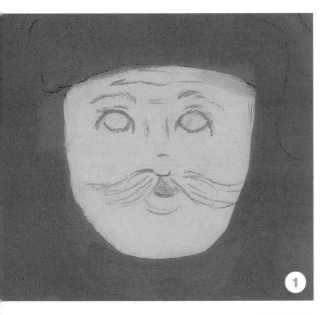

1 Basecoat

Base the face area with two or three coats of Flesh Tone. Let this dry. Transfer the facial features. Detail the facial features with a no. 10/0 liner loaded with thin Shading Flesh.

2 Shade & Highlight the Face

Shade the face with a soft side load of Shading Flesh on a no. 6 flat. Highlight the face with Hi-Lite Flesh using a no. 6 flat. Basecoat the iris with thin Desert Turquoise.

3 Detailing the Face

Paint a second highlight with Hi-Lite Flesh and Titanium (Snow) White side loaded on a no. 6 flat. Blush the cheeks with DeLane's Cheek Color. Paint the line across the top of the eye and sides of the iris with the no. 10/0 liner loaded with thin Lamp (Ebony) Black. Touch Titanium (Snow) White into the whites of the eyes.

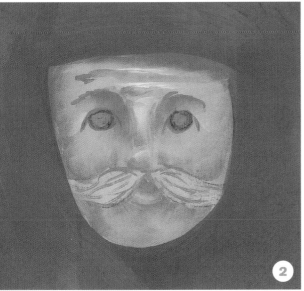

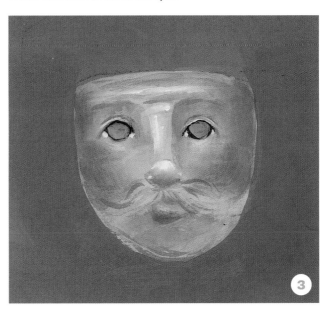

Santa on a Dictionary Cone

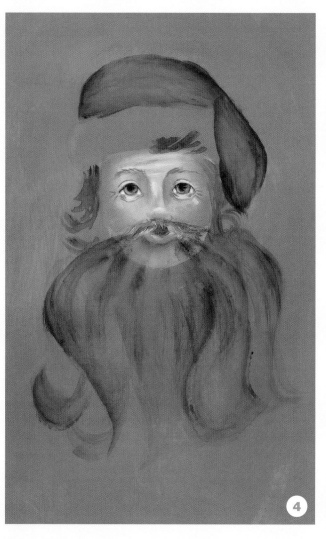

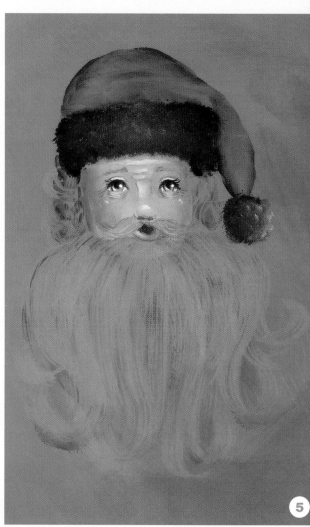

4 Hat & Beard

Shade the hat and indicate the beard with a soft side load of Burnt Umber on a no. 6 flat. Indicate hair and mustache with the same color, using the no. 10/0 liner. Paint the pupil of the eye with Lamp (Ebony) Black. Paint the nostrils and inside of the mouth with thin Burnt Umber. Detail the wrinkles and creases around the eyes with thin Burnt Sienna, using a no. 10/0 liner.

5 Additional Details

Stipple fur on the hat with an old scruffy brush loaded with Burnt Umber. Lighten the fur with a touch of Titanium (Snow) White on the dirty brush. Paint the beard and hair with a mix of Burnt Umber and Titanium (Snow) White, using a ¼-inch (6mm) filbert rake or comb. Follow the flow of the beard and hair.

Highlight the eyes with Titanium (Snow) White. Paint a touch of lash with Lamp (Ebony) Black.

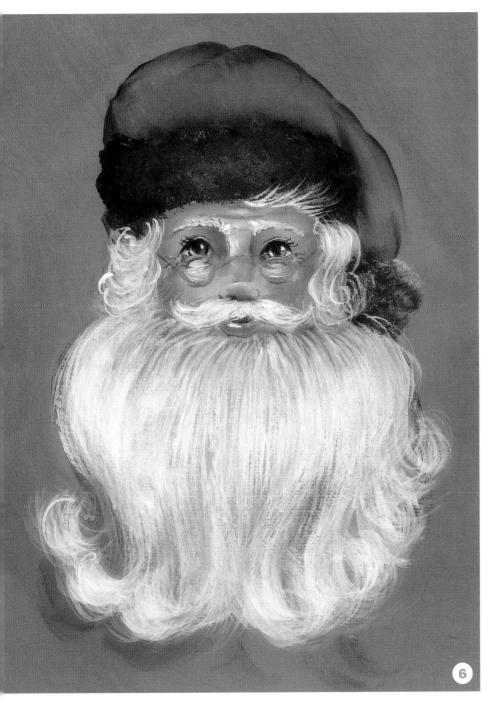

6 Adding Glasses, Final Details

Finish the face by adding glasses of Emperor's Gold. Brush a touch of Titanium (Snow) White into the glass area. Underline the rims of the glasses with Burnt Umber and highlight with Titanium (Snow) White.

Finish hair, beard, eyebrows and mustache with Titanium (Snow) White. Use the rake brush to establish these areas. Finish these areas with the no. 10/0 liner.

Varnish with a spray varnish.

"Santa Stocking"

PAT WAKEFIELD

MEDIUM: *Oils*

COLORS: **FolkArt:** *Dapple Gray (to basecoat stocking)* **tube oil colors:** *Titanium White*
• Cadmium Yellow Light • Yellow Ochre • Cadmium Red Light • Alizarin Crimson
• Ultramarine Blue • Burnt Umber • Ivory Black

BRUSHES: **Bette Bird:** *no. 1 flat • no. 4 flat • no. 8 flat • no. 1 round • no. 6/0 liner*
• ½-inch (12mm) mop • ½-inch (12mm) whisk

OTHER SUPPLIES: *FolkArt Acrylic Clearcote Spray*

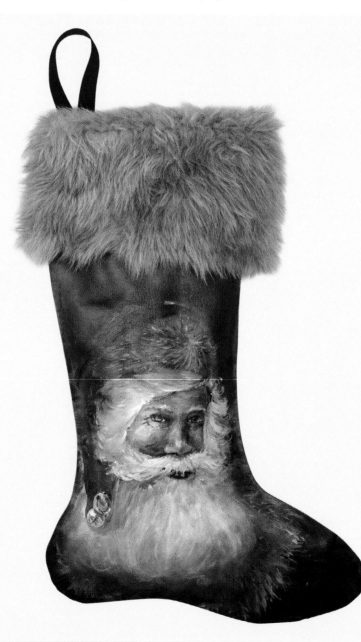

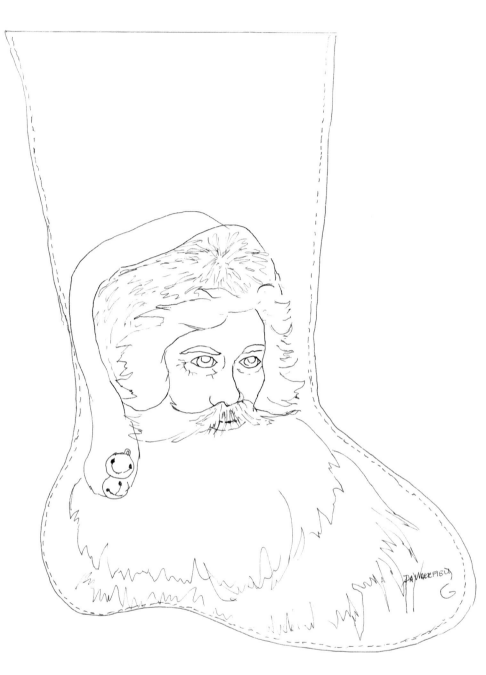

1 Line Drawing

This line drawing may be hand-traced or photocopied for personal use only.
Enlarge at 122% to bring it up to full size.

Santa Stocking

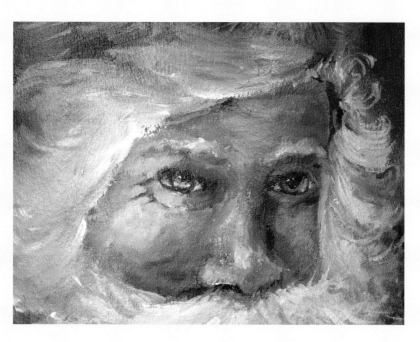

2 Paint the Eyes

Basecoat the stocking with Dapple Gray. Transfer the line drawing onto the stocking. Next, paint the eyes. Paint the iris of the eyes with a mixture of Titanium White and Ultramarine Blue. Paint the white of the eye with Titanium White. Paint the pupil with Ivory Black. Add a stripe of Burnt Umber across the top edge of the eye. Blend down into the white to create a shadow. Blend the black pupil up to touch the top of the eye. Soften the outer edge of the pupil.

Outline the eye and the iris with Ivory Black. The top edge should be thicker than the remainder. Add Titanium White to lighten the iris. Add a tiny white highlight dot.

Paint above and below the eye with Mix 1 (Yellow Ochre, Alizarin Crimson, Burnt Umber and Titanium White 2:2:2:1). Add Burnt Umber shading in the inner corner of both eyes and across the top edge on the right eye. Indicate the eyelids with a fine line of Burnt Umber. To give the effect of eyelashes, use a pointed brush to make a top eye line that is thicker and more irregular.

3 Paint the Forehead & Cheeks

Paint the forehead using Mix 1. Darken the right side, under the hair, with Burnt Umber. While the paint is still wet, paint in three lines, which follow the curved brow line, using Mix 2 (Cadmium Yellow Light, Cadmium Red Light and Titanium White 1:1:4) and Burnt Umber. Soften the lines with a mop brush. Paint the cheeks using Mix 1 for the lightest area and Mix 2 for the darker parts. Add Titanium White on the center of the cheeks. The reddish cheeks are painted with Mix 1 plus Mix 2 and Cadmium Red Light. Use Burnt Umber to add lines indicating wrinkles.

4 Paint the Nose

Paint the nose using Mix 1 and Mix 2. Blend somewhat. Add Cadmium Red Light and Mix 2 next to the cheeks. Paint the nostrils with Burnt Umber. Paint the highlights with Titanium White.

SANTA'S HAT

5 Hat Top & Fur Band

Paint the top red part of the hat with a coat of Alizarin Crimson. Paint the band of fur with a mixture of Yellow Ochre, Burnt Umber and Titanium White.

6 More Hat Details

While the Alizarin Crimson is still wet, add slip-slap strokes of Cadmium Red Light on a flat brush. Blend only slightly.

While the fur on the hat is still wet, use Yellow Ochre, Titanium White and a touch of Burnt Umber to first add strokes with the chisel edge of a flat brush and then add strokes with a round brush. Blend softly with a mop brush.

Paint the fur collar the same as the fur on the hat.

SANTA'S BEARD & MUSTACHE

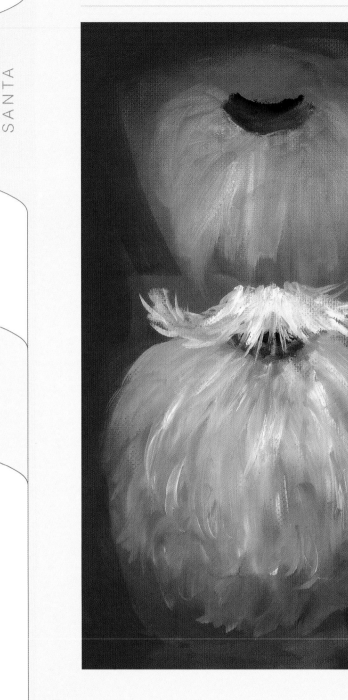

7 Hair, Beard, Mouth & Eyebrows
Basecoat all the hair with a flat brush using Mix 3 (Titanium White, Alizarin Crimson, Ultramarine Blue, Yellow Ochre 3:1:2:2 + a touch of Ivory Black.) Follow the curves as you lay on the paint. The color should be darker under the mustache. Paint the lips with Cadmium Red Light and Mix 2 (see step 3). Highlight with Mix 1 (see step 2). Paint a space between the lips with Burnt Umber. Then paint all these areas with Titanium White on a whisk brush, keeping the curve of the hair.

8 Detailing the Hair & Beard
Add more Titanium White until you have achieved the proper amount of lightness. Now use a round brush with Titanium White to give a final highlight to the hair. Blend with a mop brush. Add Titanium White strokes to the eyebrows.

JINGLE BELLS ON SANTA'S HAT

9 Basecoat
Basecoat the bells with Yellow Ochre.

10 Add Color & Blend
Add Cadmium Red Light in splotches and blend lightly.

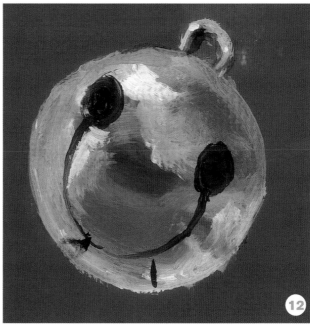

11 Add Additional Color
Add splotches of Burnt Umber and blend lightly.

FINISHING DETAILS

When paint is dry, spray lightly with FolkArt Clearcote Spray. Glue a strip of fur to the top edge of the stocking.

12 Finishing Details
Add splotches of Cadmium Yellow Light and Titanium White. Add the black holes and splits with Ivory Black. Paint the loop on the top of the bell with Yellow Ochre, Ivory Black and a Titanium White highlight.

"Santa's List"

JUDY MORGAN

MEDIUM: *Acrylic*

COLORS: **Delta Ceramcoat:** *Brown Velvet • Black • Liberty Blue • Black Green • Fruit Punch • Dark Flesh • Barn Red • Royal Plum • Empire Gold • Light Foliage Green • Golden Brown • Lichen Grey • Fleshtone Base • Rain Grey • Custard • Bittersweet Orange*

BRUSHES: **Loew-Cornell:** *no. 8 flat • no. 12 flat • no. 0 round • no. 2 round • no. 6 round • no. 6 filbert • no. 8 filbert • 1-inch (25mm) wash*

OTHER SUPPLIES: *Delta Interior/Exterior Matte Varnish • dark graphite paper*

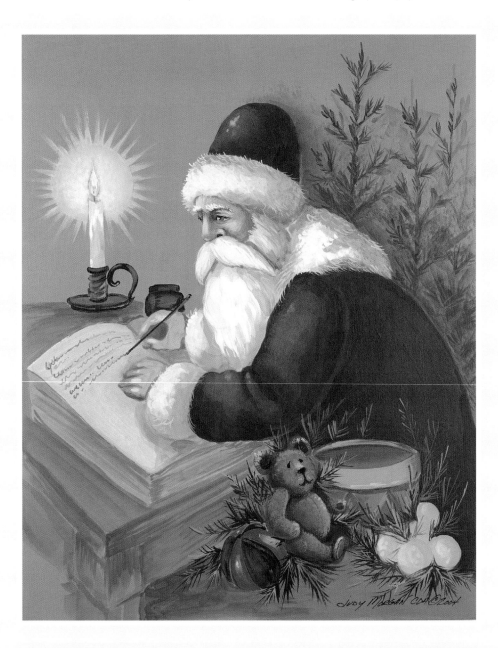

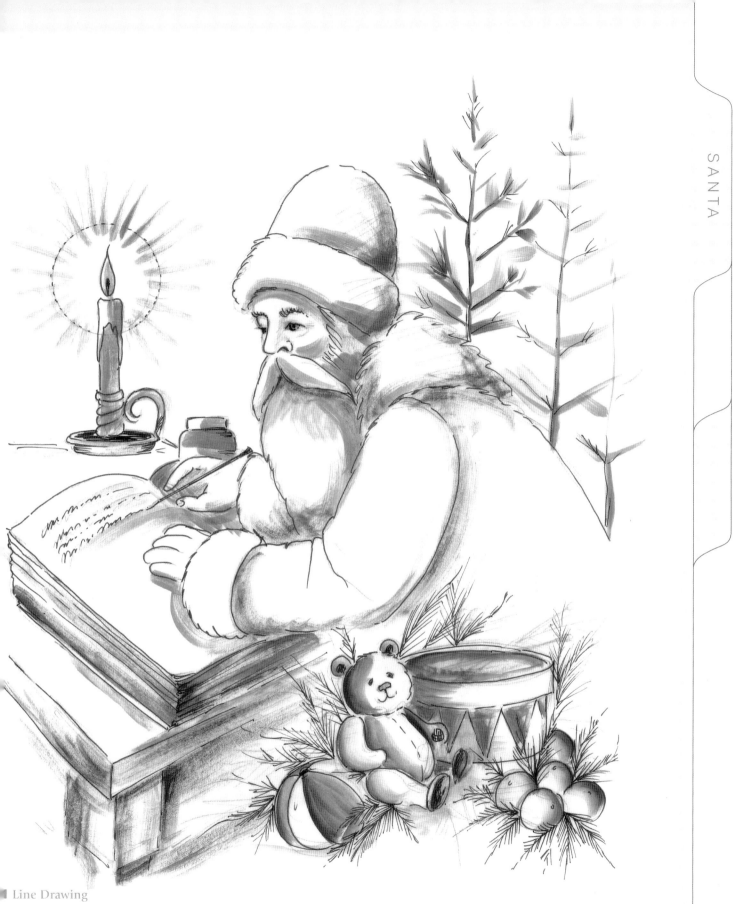

Line Drawing

This line drawing may be hand-traced or photocopied for personal use only. Enlarge at 159% to bring it up to full size.

SANTA

2 Basecoat

Basecoat the face and hands with Dark Flesh using a no. 2 round brush. Basecoat the beard, mustache, hat and coat fur with Lichen Grey, using the no. 2 round brush. Basecoat the hat and coat with Barn Red using the same no. 2 round brush.

When the paint is dry, transfer the facial features, including the nose, eyes and eyebrows. Also transfer the mustache and beard lines with dark graphite paper.

Side load a no. 12 flat brush with thinned Brown Velvet. Shade the top and bottom of the fur on the hat. Then shade under the mustache, under the hat band, on the fur collar to separate it from the hair and beard, and on the sleeve to separate it from the beard.

3 Facial Features, Shading

Use a no. 0 round and thinned Brown Velvet to line over the facial features—this will "lock" them in place during the shading and highlighting step. Pick up thinned Brown Velvet on a no. 8 flat and float a shade under the hat and around the side of the face. Float the same thinned Brown Velvet on each side of the nose and around the nostrils and lower cheek area. Fill in the eye with Brown Velvet, using the no. 0 round brush.

Using a no. 6 filbert, pick up thinned Brown Velvet plus Rain Grey and reinforce the shading, using the chisel edge of the brush to apply the thinned color. Clean the no. 6 filbert and pick up thinned Rain Grey to apply washes of this color next to the previous shade.

On a no. 12 flat, side load into Royal Plum and float Royal Plum on the back side of the hat, on the Barn Red basecoat. Also side load the Royal Plum next to the fur hat band and next to the sleeve.

Santa

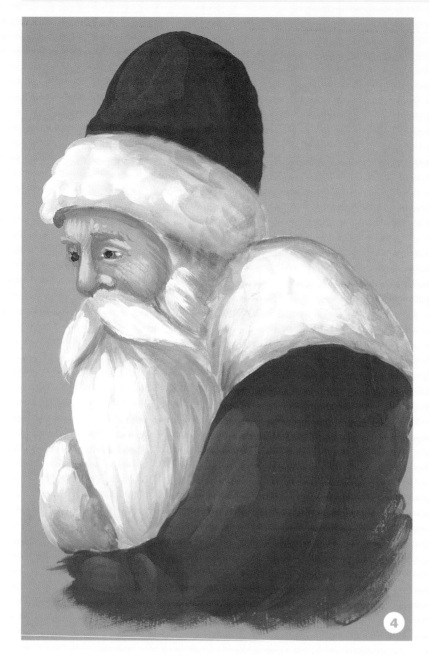

4 Facial Details

Highlight the face with Fleshtone Base and a touch of Dark Flesh, using a no. 2 round. Apply the highlight to the brow, the bridge of the nose, above the nostril, above the eye and on the cheekbones. Fill in the sclera of the eye with Fleshtone Base. Base the iris with Black. Let this dry. Highlight the iris with a backward "C" of Liberty Blue. Highlight the pupil with a tiny dot of Fleshtone Base.

Highlight with thinned Fleshtone Base and a touch of Lichen Grey, using the no. 6 filbert towards the front of the hat fur, on the mustache, the front of the beard, the middle of the collar and the front of the cuffs.

Tint the shaded areas with thinned Royal Plum, then thinned Liberty Blue. Add a second shade with Royal Plum and a touch of Black on the coat and hat.

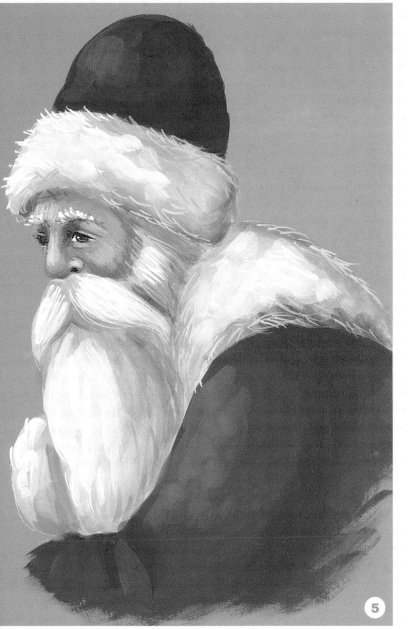

5

5 Final Details

Tint the cheek and the tip of the nose with thinned Fruit Punch using a no. 2 round brush.

Fill in the sclera of the eye with Fleshtone Base. Base the iris with Black. Let this dry. Highlight the iris with a backward "C" of Liberty Blue. Highlight the pupil with a tiny dot of Fleshtone Base.

Finish the eyebrows with Fleshtone Base "hairs" using a no. 0 round. Pull a thin line of Black across the top of the eye and fill in the nostril with Black.

The final detail on the fur and hair is small, short, choppy lines applied with a no. 0 round brush and Rain Grey, then Fleshtone Base for the lightest value.

Highlight the front of the red hat and sleeve with thinned Fruit Punch using a no. 8 filbert.

FINISHING DETAILS

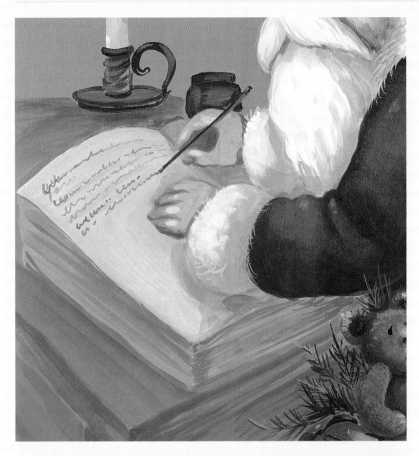

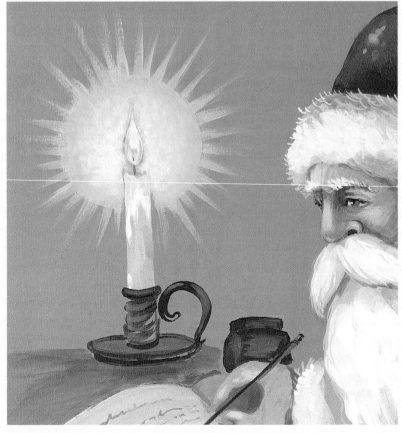

6 Table

The grain of the table is done with very thin washes of Brown Velvet using a no. 6 filbert. Let the background show through.

7 Book

Basecoat the book with Lichen Grey. Shade the spine and the edges of the pages with thinned Rain Grey using the no. 6 round. Tint the book edges with thinned Brown Velvet. The top of the page is tinted with thinned Empire Gold to reflect the candlelight. Using a no. 0 round brush and thinned Brown Velvet, squiggle in the writing, then fill in the pen with Brown Velvet and Black. Shade under the fur cuff with Rain Grey.

8 Candle

Basecoat the candleholder with Black. Highlight with Rain Grey using the no. 2 round. Basecoat the candle with Lichen Grey and basecoat the candle drip with Fleshtone Base. Tint the right side of the candle with thinned Liberty Blue. Basecoat the circle of candle glow with Custard. Pull "spikes" of Custard out from the circle. Tint the edges of the candle glow and the light spikes with thinned Bittersweet Orange. Highlight the center of the candle glow with Fleshtone Base. Basecoat the candle flame with Fleshtone Base. Shade the bottom of the flame with Bittersweet Orange. Pull a short, thin line of Brown Velvet and Black for a wick.

9 Ink Bottle

Basecoat the bottle with Black. Highlight the left side with a side load of Rain Grey and Black, using a no. 8 flat.

10 Background Pine Trees

Using a no. 2 round, basecoat the trees and branches with thinned Black Green. Highlight the branches with Black Green and a touch of Light Foliage Green.

11 Drum

Basecoat the top of the drum with Brown Velvet, the horizontal bands with Golden Brown and the alternate triangle shapes with Liberty Blue and Fruit Punch. Shade the top of the drum with Brown Velvet and a touch of Black at the top edge. Shade the bands on each side with a float of Brown Velvet, using a no. 8 flat. Highlight the center of the top band with Golden Brown and a touch of Custard, using a no. 2 round. Shade under the band with a mix of Liberty Blue and a touch of Black.

12 Teddy Bear

Basecoat the bear with Brown Velvet. Shade with Brown Velvet and a touch of Black, using a no. 8 flat. Highlight the top of the ears, the nose, muzzle, belly and the top of the arms and legs with casual brush dots of Golden Brown. Add Custard to the Golden Brown and lighten the highlights on the ears and on the top of the nose and the tip of the foot. Basecoat the eyes, nose and mouth line with Black, using a no. 0 round.

13 Oranges

First, basecoat with Custard, then basecoat with Bittersweet Orange. Highlight the left side with brush dots of Custard.

14 Ball

Basecoat the alternate stripes with Fruit Punch and Black. Highlight the Fruit Punch with a dot of Bittersweet Orange. Highlight the Black with a dot of thinned Rain Grey.

15 Pine Boughs & Finishing Details

Using a no. 0 round brush, fill in the pine boughs with Black Green. Highlight the needles with Light Foliage Green.

Use a 1-inch (25mm) wash to shade behind Santa with a wide float of Royal Plum. Let dry. Finish with a water-based varnish such as Delta Interior/Exterior Matte Varnish.

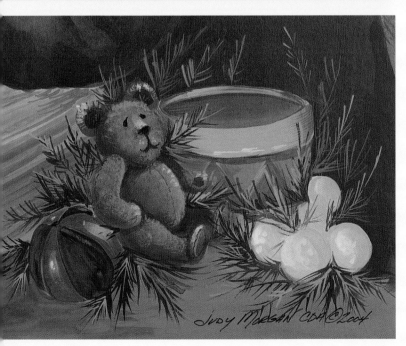

"Santa Claus Tray"

KERRY TROUT

MEDIUM: *Acrylic*

COLORS: **DecoArt Americana:** *Burnt Umber • Grey Sky • Cadmium Red • Antique Rose • Napa Red • Titanium (Snow) White • Base Flesh • Hi-Lite Flesh • French Grey Blue • Lamp (Ebony) Black • Honey Brown • True Ochre • True Red • Graphite • Yellow Ochre*

BRUSHES: **Loew-Cornell:** *7300 Series no. 8 flat shader • 7300 Series no. 14 flat shader • 7520 Series $\frac{1}{2}$-inch (12mm) filbert rake • 7120 Series 1-inch (25mm) filbert rake • 7000 Series no. 1 round • 7050 Series no. 1 script liner*

OTHER SUPPLIES: *DecoArt DuraClear Satin Varnish • DecoArt Americana Spray Sealer • DecoArt Gel Stain (Walnut) • soft cloth • toothpick*

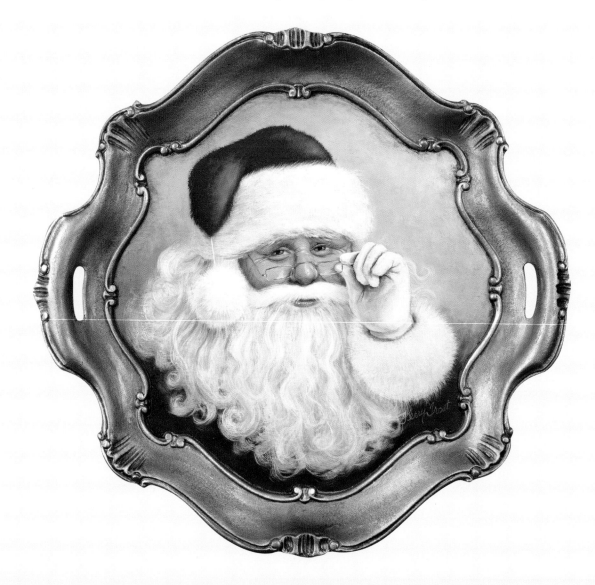

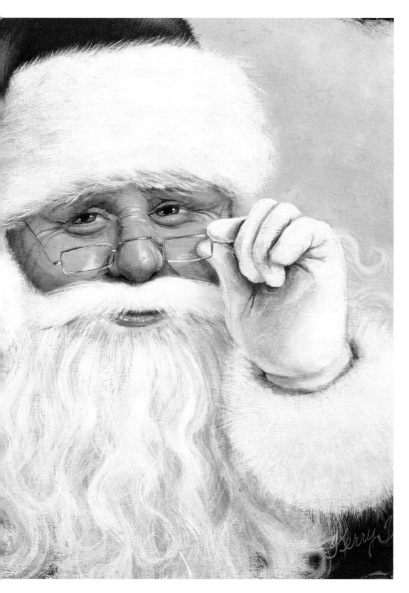

1 Background

Trace the basic design from the picture on page 42. Paint the background color down to Santa's shoulders, using the no. 14 shader with True Ochre. Let dry. Use Honey Brown on the far left of the background and dry-brush the edge into the background color. This will act as a shadow.

On the upper right edge, paint a 2:1 mix of Titanium (Snow) White and True Ochre and blend into the background. (The shadow and highlight should be applied with slip-slap, choppy strokes for a mottled look.)

2 Coat

Paint the coat on the left side using Napa Red. Drybrush this slightly up into the Honey Brown shadow. Paint the coat True Red on the right side and blend it into the background by the arm. There should be no real defined line where the coat stops and the background begins. Be sure to paint up far enough so that when the beard is painted, some red will show through the curls at the end.

3 Face

Basecoat the face with Base Flesh and let dry. Take care to paint around the eyes. You may have to transfer the nose again if the base color covered your lines. Mix up a dark flesh color with three parts Antique Rose, two parts Burnt Umber and one part Base Flesh. Mix enough to use later.

Use the no. 14 flat to float this color around the cheeks, against the beard and mustache and on the brow under the fur trim. Let dry.

SANTA'S EYES

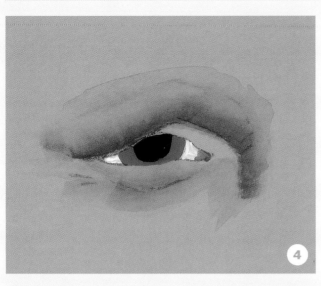

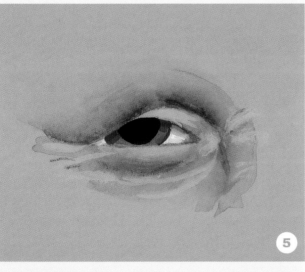

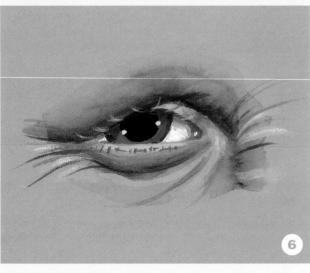

4 Eye Whites & Iris

Paint the whites of the eyes with Titanium (Snow) White tinged with a touch of French Grey Blue. Paint the irises with French Grey Blue and the pupil with Lamp (Ebony) Black. Mix Antique Rose with a touch of Titanium (Snow) White and paint the corner of the eyes. Blend this slightly into the white of the eye. Use the dark flesh mixture (see step 3) on a no. 14 flat to float around the eyelid and bridge of the nose. Apply this color along the crease of the lower lid with the small round brush and quickly blend it out to diffuse any hard line.

5 Eye Details

Mix a very small amount of French Grey Blue with Titanium (Snow) White and paint this below the eyelid as a shadow on the white of the eye. Add a touch of Lamp (Ebony) Black to the French Grey Blue to do the same on the irises. Use the small round to outline the iris with this color. Add a touch of Titanium (Snow) White to the pink that made the corner of the eye and dot it on top of the first pink color. Using the small round and thinned Hi-Lite Flesh, stroke in lines under the eyes, over the bridge of the nose and on the outside of the eye. Highlight the upper and lower lids with this color also.

6 Add "Crinkles"

With the liner brush, make a watery blend of Burnt Umber and paint on the wrinkles, starting at the eye and stroking outward, tapering as you end a stroke. Deepen the lid crease with this color as well. Mix Graphite and Titanium (Snow) White (1:1) and stroke on tiny lower lashes with the small round, then stroke on longer upper lashes. Pick up a bit of Titanium (Snow) White on your dirty brush and stroke along a few of the upper lashes. Use the point of a toothpick to dot on Titanium (Snow) White highlights on either side of the pupils and in the corner of the eyes.

SANTA'S BUTTON NOSE

7 Basecoat the Nose

With the large flat shader, float the dark flesh color (see step 3) around the lower edges of the nose, then against the lower line of the nose and cheek creases. Bring some of this color up along the nose (left side) and blend out any hard lines.

8 Shadows & Wrinkles

Use a very thin mix of Burnt Umber and float this on top of your previous float, deepening the shadows under the nose and along the side. Use the liner to create wrinkles on the bridge of the nose. Darken a small amount of Burnt Umber with Lamp (Ebony) Black and apply to the lower edge of the nose to suggest nostrils.

9 Final Details

Using the small round brush, stroke on Hi-Lite Flesh on the right side of the nose, along the bridge and nostril. Stroke on final highlights of Titanium (Snow) White along the bridge of the nose, right nostril and dab loosely on the right side of the tip of the nose.

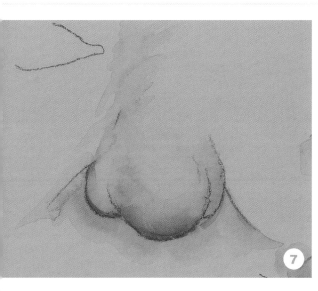

Santa Claus Tray

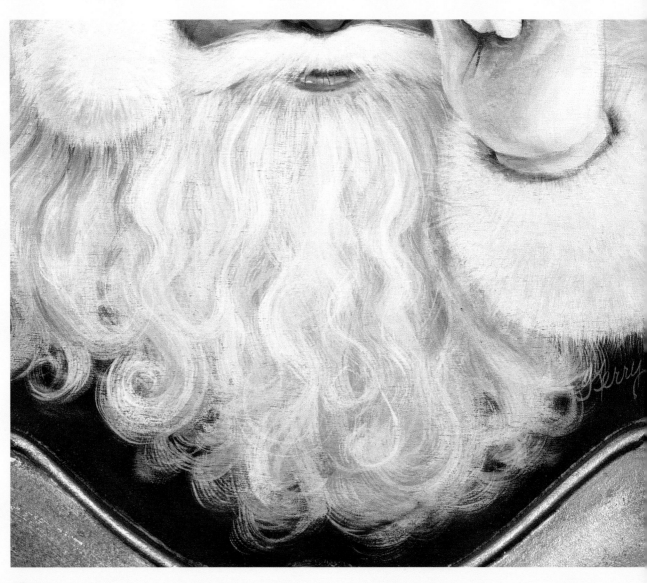

10 Lip

Paint the lip with a mix of Antique Rose darkened with Burnt Umber (about 2:1) on a small round brush. With the dirty brush pick up some Titanium (Snow) White and stroke horizontally across the lip. When dry, pick up the Antique Rose/Burnt Umber lip color mix on the liner brush and stroke in several fine wrinkles vertically on the lip. Arch them slightly to keep them looking natural.

11 Beard, Hair & Mustache

Mix Yellow Ochre into Titanium (Snow) White just enough to tinge the Titanium (Snow) White slightly (about 1:4). This is the undercoating for the beard, hair and mustache. Paint this onto those areas. Next use the large filbert rake to stroke on the first layer of whiskers. Water down Grey Sky so it flows easily from the brush and apply whiskers in long, wavy strands. Curl the ends of the whiskers. On the mustache, the strokes should begin at the base of the nose and flare outward and down. The last layer of whiskers is Titanium (Snow) White applied with the same rake. Be sure to make wavy strokes and soft curls at the ends.

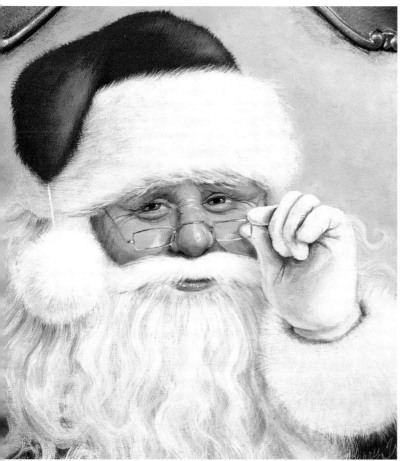

12 Hat Trim, Pom-Pom, Cuff and Glove

Basecoat the hat trim, pom-pom, cuff and glove with a 2:1 mix of Titanium (Snow) White and Grey Sky. Use the large rake and thinned Titanium (Snow) White to stroke on fur. Use short, straight, tapered brush strokes and pay attention to the direction of the nap. The whitest fur (straight Titanium (Snow) White) is to be applied to the right sides of all areas. Be sure to leave grey areas on the left to show shadow. For heavier shadows, as inside the cuff and under the pom-pom, use thinned Graphite sparingly and stroke it into the fur going in the same direction as the fur.

Shade the glove using Graphite (with the small round brush) at its darkest in the folds of the palm and fingers. Blend out to diffuse hard lines. Use the no. 8 shader and paint the right side (highlighted side) of the glove and fingers with Titanium (Snow) White.

13 Hat

Basecoat the hat with True Red. Shade with Napa Red and highlight with Cadmium Red. Then use a touch of Cadmium Red and Titanium (Snow) White (1:1) to stroke in the lightest highlights in the center of the Cadmium Red areas. The hat has a short, furry texture to it, so your strokes must reflect that. Use the ¹/₂-inch (12mm) rake to make a soft, furry nap. Be sure to extend your strokes out over the edges of the hat and taper the ends. You will also have to go back and complete the upper edge of the white fur trim. Load the large rake with watered down Titanium (Snow) White and stroke outward and to the right, overlapping the red fabric of the hat. Use the liner brush to paint a Titanium (Snow) White cord from the pom-pom to the tip of the hat.

14 Glasses

Use the liner brush to paint in the glasses with a thin line of Honey Brown. Use the liner to shade with strokes of Burnt Umber and highlight with streaks of Titanium (Snow) White.

FINISHING DETAILS

If you have painted this on a tray, apply two coats of DuraClear Varnish to the tray only, sanding lightly between coats. Let dry overnight. Apply a thin coat of DecoArt Gel Stain (Walnut) with a no. 14 flat brush. Immediately clean with a soft cloth, starting in the center and making circular wipes out to the edges. Remove any excess stain. Let dry. Apply spray varnish to the entire tray. Let dry overnight before use.

Santa Tumbler

CAROL MAYS

MEDIUM: *Acrylic on glass*

COLORS: **Liquitex Glossies:** *Orange • Blue • Red • Green • White • Almond • Brown • Black*

BRUSHES: **Royal:** *Series SG595 Soft-Grip Gold Taklon 5/0 short liner • Series RG730 Golden Taklon ¹⁄₄-inch (6mm) comb • Series SG4010 Soft-Grip White Nylon no. 2 short shader • Series SG4010 White Nylon no. 4 short shader • Series 5005 Langnickel no. 12 sable • Series 5005 Langnickel no. 20 sable*

OTHER SUPPLIES: *rubbing alcohol • lint-free paper towels • adhesive tape • stylus • fine-tip permanent pen • toothpick • clear glass tumblers*

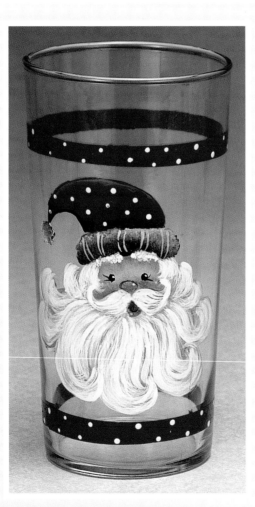
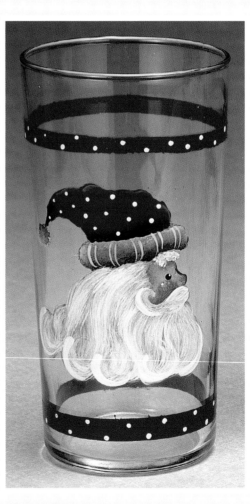

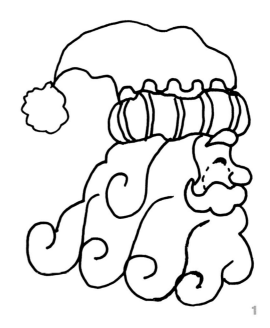

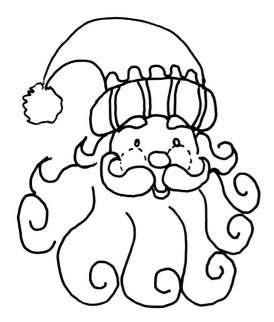

1 Line Drawing

This line drawing may be hand-traced or photocopied for personal use only. It is shown here at full size.

2 Prepare the Glass

Clean the glass surface with rubbing alcohol and lint-free paper towels. Measure down at least 1-inch (25mm) from the top of the glass and mark around the glass with a fine-tip permanent marking pen. Wrap adhesive tape around the glass right above the marks. If the glass is flared, you may have to make adjustments to the tape. Just make sure the very bottom of the tape (the area next to the marks) is smooth and flat. If it isn't perfect, it won't show; the Santa will be the focal point. Apply another strip of tape ¼-inch (6mm) below the first piece of tape.

At the bottom of the glass, apply a strip of tape even with the bottom edge of the glass. Then leave ¼-inch (6mm) spacing and apply another strip above that strip. Smooth the seams with a palette knife or your thumbnail. Your Santa design should fit in the area between the red stripes, so you may have to adjust the size of the Santa face.

Santa Tumbler

3 Paint a Stripe

Use your no. 20 sable or any large soft brush to dab Red all the way around both taped-off areas. Add two coats, letting it dry thoroughly between coats.

4 Remove the Tape

Remove the tape. If any little mistakes show after you take off the tape, just use a craft knife or a single edge razor blade to clean up the area. This will not be a perfectly straight line, but that's okay; it won't be noticeable once the Santa face has been added.

5 Basecoat Santa's Face

Center the line drawing between the red lines and tape it to the inside of the glass. Use your no. 2 shader and Almond to basecoat Santa's face; you will need two coats. Using this same brush, basecoat the beard with a light blue-gray mixture of Blue, Orange and White (1:1:4). Fill in the beard using shape-following strokes. One coat will be sufficient; you will be covering this up later with White.

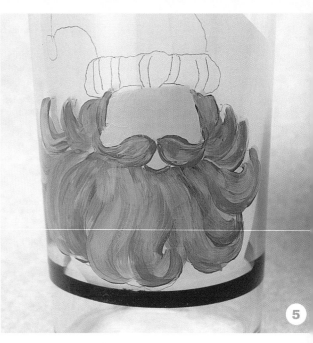

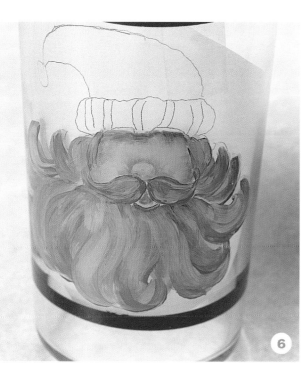

6 Shade Santa's Face

Load the same brush with Almond, tip the corner in Brown and shade Santa's face around the eyes, nose and mouth areas and along both sides.

7 Cheeks and Mouth

Load your no. 12 sable with Red and Orange (1:1) and add a tiny touch of White; dab in the cheeks and nose. Use the no. 5/0 liner with the same mixture to paint Santa's mouth. The cheeks always look brighter before the rest of the detail is put on the face. Make sure the cheek color is dark enough—if you think they're too bright, they're just right. If you think they're just right, they're too light.

Santa Tumbler

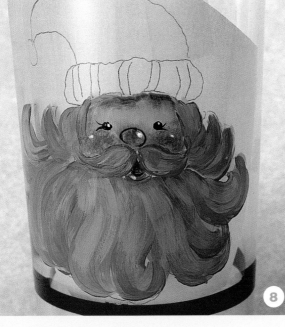

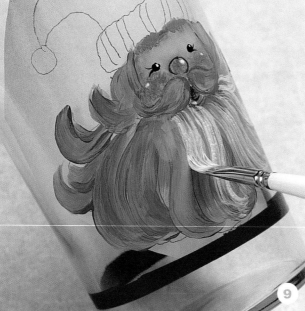

8 Facial Details

Use the large end of your stylus and Black to dot in Santa's eyes. When the eyes have completely dried, use the no. 5/0 liner and Black to add little eyelashes. Still using the same brush and Brown, darken the upper points of the mouth and outline the bottom lip and the nose. Using the same brush, add highlights with White. Keep all the highlights on the same side, either on the right or on the left.

9 Eyebrows and Beard

Use the light blue-gray mixture from step 5 with your no. 5/0 liner to dab in the eyebrows. Thin White with a little bit of water. Load the ¼-inch (6mm) comb by pushing down hard into the White so the brush hairs are well separated and completely filled with paint. Paint the beard using shape-following strokes; also paint the mustache. This will take approximately three coats of paint; make sure each coat is completely dry before adding the next coat. If the beard seems to need more coverage on the ends, you can stroke up from the ends and in toward the face.

10 Hair

Still using the same brush and paint, add little soft hairs around the face. Also tap White into the eyebrows.

11 Define the Beard

Use your no. 5/0 liner and White to define the beard further by outlining each separate beard section. Work from the ends in toward the face.

12 Santa's Hat

Using your no. 4 shader, basecoat Santa's hat with Red. Once this has dried, add a second coat of Red. Make a darker red mixture of Red and Green (10:1) and use your no. 4 shader to tap in shading around the brim and near the tassel end of the hat. Double load the same brush with White and Red and add a highlight along the top edge of the hat.

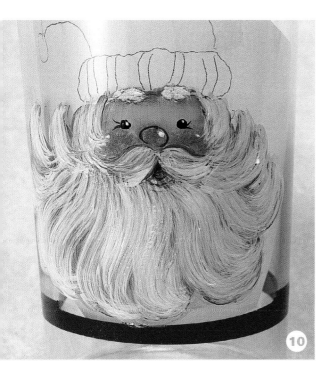

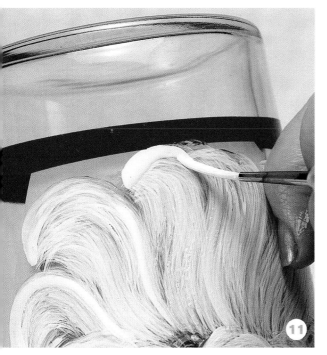

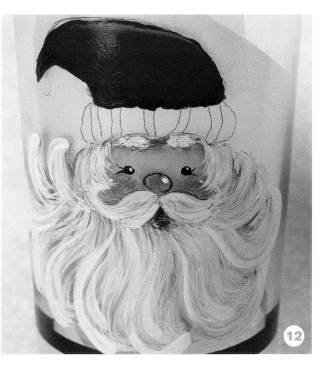

Santa Tumbler

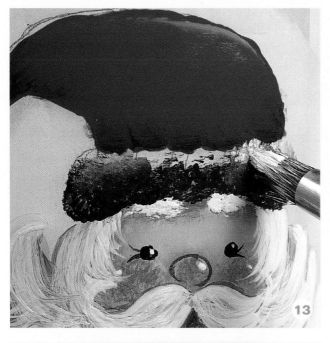

13 Hat Trim

For the hat trim, make a dark green mixture of Green and Red (10:1) and use your no. 12 sable to pounce the mixture in along the bottom. Side load with White and tap in the top section of the trim as shown. Also tap in the tassel.

14 Hat Details

Once this has completely dried, use your no. 5/0 liner and White to add the stripes on the hat brim in sets of two. Use a dulled toothpick to add White dots on the hat and on the red stripes going around the glass. Let those dry, then remove the line drawing from inside the glass.

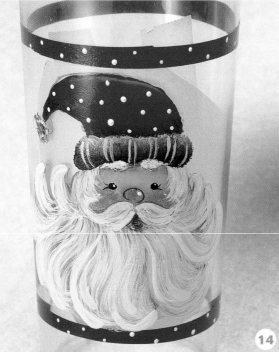

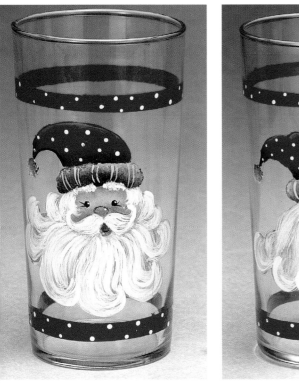 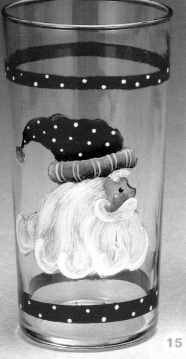

15 Final Details

Place the Santa tumbler in the oven and bake according to the paint manufacturer's instructions.

Below are three frosted glass ornaments, each with a slightly different version of the Santa faces that were painted on the tumblers. Because the ornaments are much smaller, the faces are not nearly as detailed. I outlined the edge of each ornament with Red to draw attention to its shape.

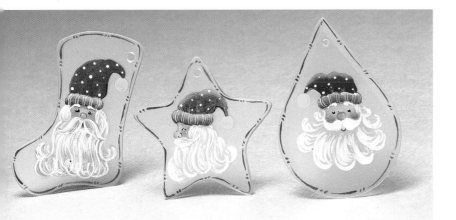

"Starry Night Santa"

DeLane Lange

Medium: *Acrylic*

Colors: ***DecoArt Americana:*** *Napa Red • Titanium (Snow) White • Antique White • Medium Flesh • Payne's Gray • Boysenberry Pink • Taffy Cream • DeLane's Deep Shadow • Light Cinnamon • Raspberry • Emperor's Gold (Metallic) • Neutral Gray • Yellow Ochre • Moon Yellow • DeLane's Cheek Color • Soft Black • Midnite Blue*

Brushes: *no. 8 flat • no. 12 flat • no. 20 flat • no. 1 round • no. 4 round • no. 1 liner • comb brush*

Other Supplies: *wood sealer • tack cloth • sandpaper • blue graphite paper*

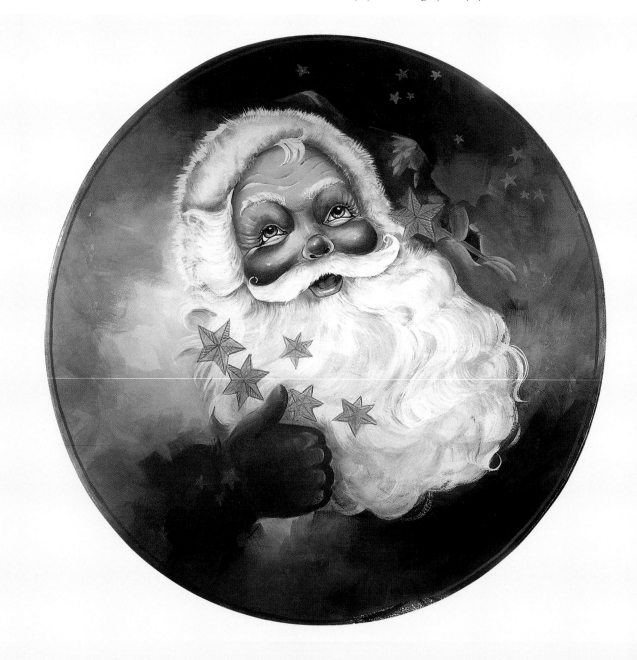

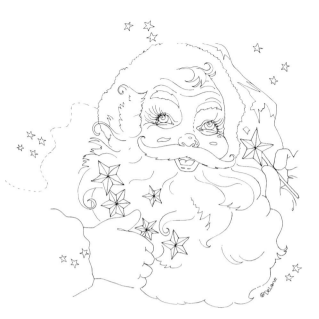

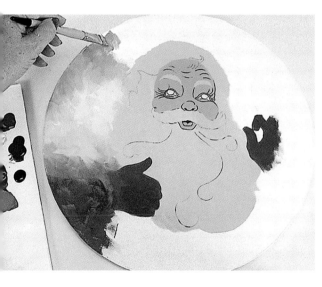

1 Line Drawing

This line drawing may be hand-traced or photocopied for personal use only. Enlarge at 111% to bring it up to full size.

2 Preparation & Basecoating

If painting on wood, sand the surface and then seal with wood sealer. Remove dust with a tack cloth. Basecoat the top with Titanium (Snow) White. Apply the basic line drawing with blue graphite paper. Carefully lift the line drawing and graphite paper to check the transfer.

Using a no. 8 flat, basecoat Santa's gloves with Medium Flesh and his fur and beard with Antique White. Reapply the line drawing details of the facial features. Basecoat the eyes and eyebrows with Titanium (Snow) White using a no. 4 round brush. Outline the facial features with Soft Black.

3 Background

Use a no. 12 flat to scumble. This is a gradual process; do not clean the brush between colors. Begin by loading the brush with Moon Yellow. Work the Moon Yellow around the left side of Santa's face. Then place a little Yellow Ochre above Santa's left hand. Quickly work the Yellow Ochre out to the edge. Add some Boysenberry Pink near the sleeve, using a no. 8 flat.

Using a no 12 flat, work in some Light Cinnamon mixed with Payne's Gray on the left side, under Santa's beard and by his face. Float a strong patch of Payne's Gray under the hand. Continue scumbling a little Titanium (Snow) White to soften the Payne's Gray. Consecutively use Payne's Gray, Raspberry and Light Cinnamon, working these colors together until you're happy with the color combinations. The Payne's Gray and Light Cinnamon are particularly noticeable toward the bottom of the beard. Come back with Titanium (Snow) White and Payne's Gray, keeping the colors very neutral as you move toward the right side. Scumble more Raspberry on top of the right hand. Then work in more Payne's Gray. A nice dark area is needed where the Payne's Gray and Light Cinnamon are the predominant colors. Continue working these colors up to the edge of Santa's hat, where you should begin introducing the Light Cinnamon, Payne's Gray, Titanium (Snow) White and a little bit of Raspberry. Mesh Payne's Gray and Titanium (Snow) White into the yellow as the colors meet on the other side.

Starry Night Santa

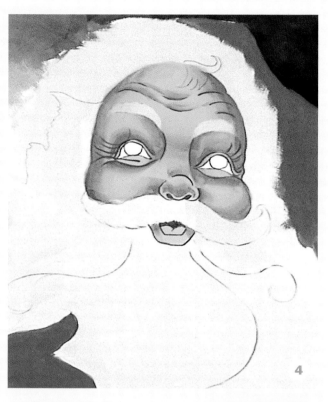

4 Shade the Face

Reapply the facial details with graphite paper and the line drawing. Use a no. 12 flat and begin floating DeLane's Deep Shadow around the hairline and onto the nose between the nostrils. With the paint side down, float wrinkles on Santa's forehead, down the bridge of his nose, underneath his eyes and a little bit above and onto his nose.

5 Deepen Shading & Shadows

Float Light Cinnamon onto the same areas using a no. 12 flat. Continue around his face, above the eyes, down each side of the bridge of the nose, on the fat pockets underneath the edges of his cheeks and on the middle of his nose (excluding his forehead).

Still using the no. 12 flat, deepen the shaded areas with a little Soft Black. Float DeLane's Cheek Color on the top and bottom of each of Santa's cheeks.

6 Highlight

Add wrinkle highlights on Santa's forehead with floats of Taffy Cream on a no. 12 flat. Float Taffy Cream above the eyebrow, between the eyebrows and eyes, on the fat pockets underneath his eyes and on the centers of his cheeks. Reinforce the first highlights using a no. 4 round and Titanium (Snow) White.

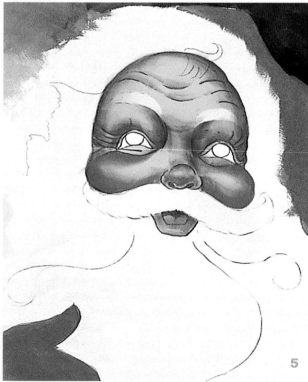

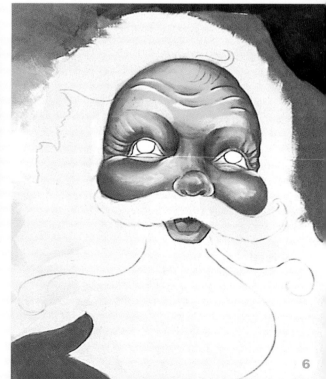

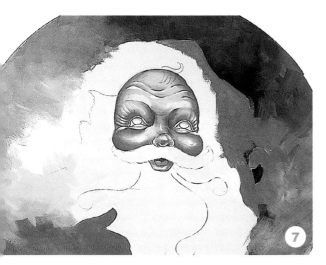

7 Sharpen Highlights

Using Titanium (Snow) White and a no. 1 round, add the final highlights to Santa's eyes, cheeks, nose and lips.

8 Details

Basecoat Santa's irises with a no. 4 round and Light Cinnamon. Paint the pupils and eyelashes using Soft Black. Highlight Santa's eyes, using just a small comma stroke, with a no. 1 liner and Emperor's Gold.

9 Shade the Nose, Cheeks, Lips, Fur & Beard

Using a no. 20 flat, deepen the shading on the nose, cheeks and lips with a float of Boysenberry Pink. If you want to give Santa a cooler look, just add a light wash of Payne's Gray on the nose, cheeks and lips. Paint the lips in the same manner with a float of DeLane's Cheek Color, then deepen with a float of Boysenberry.

Begin establishing the shaded areas on the bottom half of Santa's beard and his eyebrows with a no. 20 flat and floats of Neutral Gray. Add a little Light Cinnamon underneath his nose, mustache and the rest of the beard.

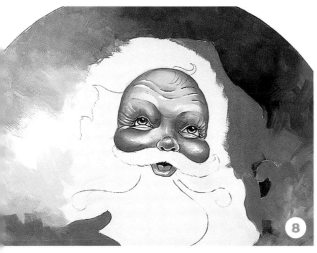

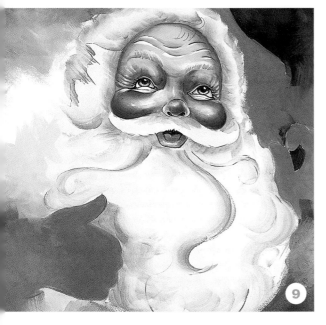

Starry Night Santa

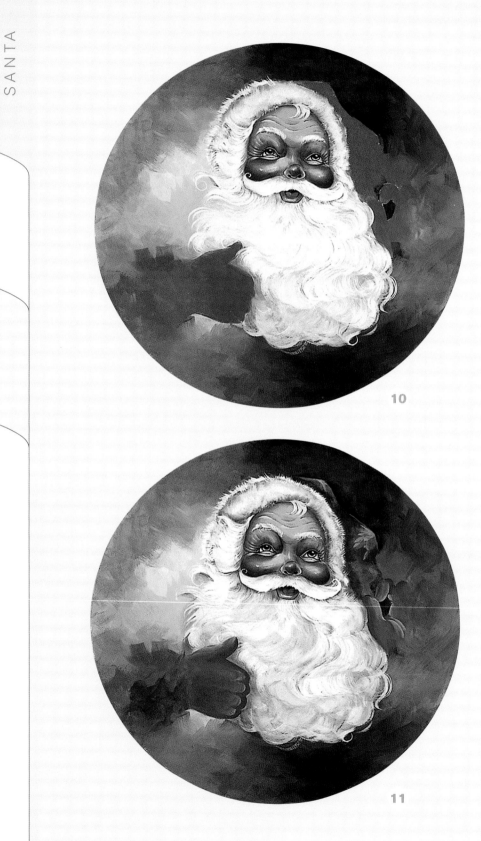

10

11

10 Finish the Fur & Beard

Using a comb brush, apply Titanium (Snow) White in light, fluffy strokes. Allow the Payne's Gray and Antique White to show through on the eyebrows, mustache, fur and beard.

Stroke in the flyaway hairs using a no. 1 round loaded with Titanium (Snow) White.

Using a no. 20 flat, float Payne's Gray to separate the locks of hair and shade around Santa's left hand, underneath his mustache and shade the lock sticking out from his hat. Next, deepen the curl on the left and the beard using Soft Black. Then float a little Yellow Ochre and Boysenberry Pink on his beard to make it more interesting.

11 Gloves, Arm & Hat

Basecoat Santa's hat with a no. 12 flat and Napa Red. The hat stops where it goes to the stars on his right hand. On his left arm, use a dirty brush and the following colors consecutively—a little Napa Red, Boysenberry Pink and a little Raspberry to make the left arm appear to move forward. Create the wrinkles in Santa's hat with Raspberry strokes and Raspberry mixed with Titanium (Snow) White for the highlights. Use Titanium (Snow) White floats for the final highlights.

The right glove has a negative space which is created using a no. 12 flat loaded with Soft Black. Shade the gloves with Light Cinnamon and highlight with Yellow Ochre. There's a tiny bit of Titanium (Snow) White on the tip of the left hand thumb and on the top knuckle, but none on the right—just a Yellow Ochre highlight.

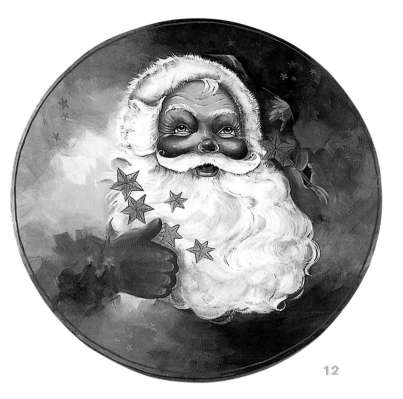

12

12 Stars

Paint the big stars using a no. 6 or 8 flat and Emperor's Gold. Outline them with Light Cinnamon. Float some Light Cinnamon on one side of the little triangles on the connecting stars. Paint the outside edges with Midnight Blue and Boysenberry Pink using DeLane's Border Tool.

FINISHING DETAILS

Paint the border line using a liner brush and Boysenberry Pink. The bottom of the box is painted with Payne's Gray. You can also add stars or scumble the bottom and then add stars.

CHAPTER **2**

Painting a Snowman

The other symbol of holiday fun is the snowman. In this chapter you'll find snowmen painted in various styles—primitive, festive and portrayed as snowmen and women. You'll also learn how to paint a detailed snowperson's face, clothing, hat and feathered friends.

Choose your surface and get painting! Any of the following snowmen will add winter fun to your artwork.

"Jolly Snowman"

JEAN ZAWICKI

MEDIUM: *Acrylic*

COLORS: **DecoArt Americana:** *Titanium (Snow) White • Buttermilk • Charcoal Grey • Midnite Green • Blue Mist • Blue Haze • Yellow Ochre • Brandy Wine • Napa Red*

BRUSHES: **Loew-Cornell:** *Series 7300 no. 2 flat shader • Series 7300 no. 4 flat shader • Series 7300 no. 6 flat shader • Series 7300 no. 10 flat shader • Series 7350 no. 1 fine liner*

OTHER SUPPLIES: *graphite paper*

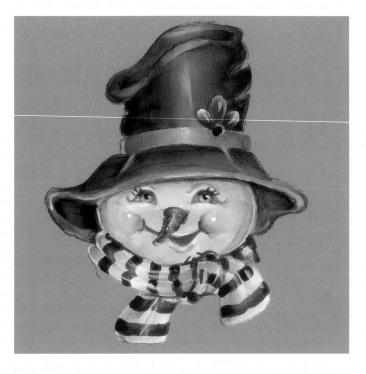

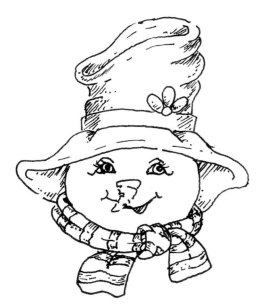

1 Line Drawing

This line drawing may be hand-traced or photocopied for personal use only. It is shown here at full size.

2 Float in the Hat, Face & Scarf

Lightly float in the shape for the hat with Midnite Green. Lightly float in the shape of the face and scarf with Buttermilk. You should still be able to see your tracing lines through this thin, floated layer of color.

3 Draw the Face

Draw in the shape of the upper lash lines and the mouth with Charcoal Grey. Float in additional Buttermilk to strengthen the color on the face and scarf. Further detail the hat with more floated Midnite Green.

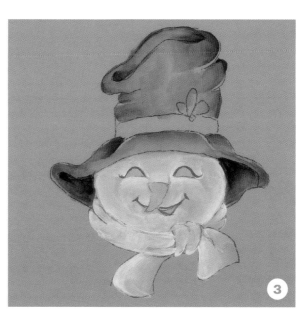

TAKE NOTE

Most of the work is done with floated color. Occasionally, paint will be slightly thinned and then loaded fully across a flat shader to apply a thin wash over the entire area. Unless otherwise specified, the work is done with floated color techniques.

Side load the near side of the brush by blending into a pile of paint, then blend out about one-half the width of the brush selected. Work in and out just slightly, but never further than the width of the brush. You will retain just a bit of clean water in the brush on the far side so as not to leave a hard line along the outside edge.

For a double load, load one value for floated color as described above, then blend just the very edge of the same side of the brush into the second color.

Trace the line drawing with the lightest possible graphite color.

Jolly Snowman

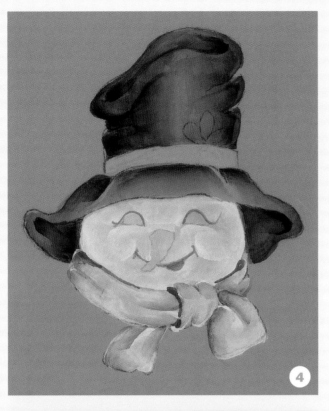

4 Deepen & Add Details

Begin to deepen the Midnite Green along both sides of the top of the hat, the folds on the brim front, the top area and under the brim areas.

Wash Buttermilk over the entire face and scarf until the background color is neutralized, going right over the facial features.

Shade the folds of the scarf with Midnite Green, floating the color very lightly. Highlight forward areas as shown with Titanium (Snow) White.

Fill in the mouth opening with a small amount of Charcoal Grey.

Add the hat band with a no. 2 flat shader loaded into Blue Mist.

5 Add Color

Intensify all the hat areas with more floated Midnite Green.

Shade the side and lightly along the bottom edge of the face with a brush blend of floated Midnite Green, adding just a hint of Charcoal Grey to soften this shading color. Float in the iris of the eye with Blue Mist, then float the very outside edge of each side of the iris with a hint of Blue Haze. Drop a Midnite Green dot into the exact center of each eye with your fine liner. Keep both dots the same size. Outline the carrot shape of the nose with Brandy Wine mixed with a touch of Charcoal Grey, using the liner brush. Allow to dry. Brush blend a bit of the Yellow Ochre with some Brandy Wine and cover the entire carrot with this soft orange mix on a no. 2 flat shader.

Use a no. 2 flat with a good chisel edge to draw in the red stripes on the scarf using Brandy Wine.

Add a Blue Haze center loop on the hat trim, then highlight it a bit on the upper right with Blue Mist. Use any soft pink to shape the two outside teardrop shapes. Then shade up on each, beginning at the bottom, using Brandy Wine. Shade as needed on either side of the hat band by floating Blue Haze in toward the center, but DO NOT meet. Leave some of the center area the Blue Mist color.

Float in a hint of Charcoal Grey to create an eyelid crease above each eye.

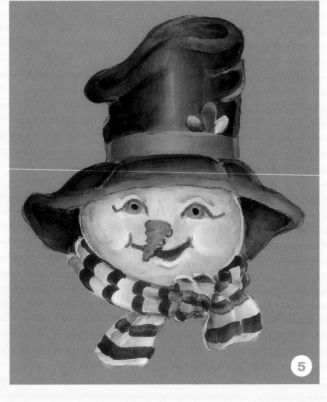

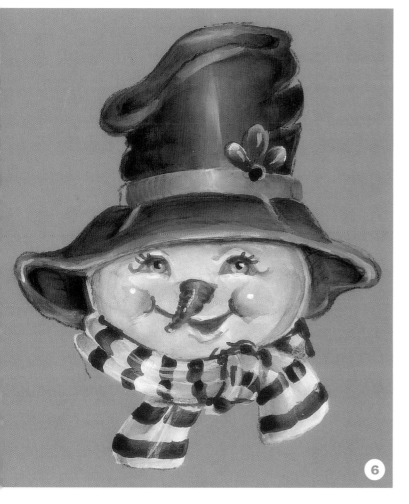

6 Final Details

Add a small, round circle of Napa Red below the little teardrop shapes of the hat trim on the hat band. Highlight the middle of the hat band with Titanium (Snow) White, adding a bit of the Titanium (Snow) White right above the band on the hat itself, as well as intermittently on the outer edge of the top and hat brim. DO NOT make it a solid line.

Shade the Brandy Wine stripes at the top and bottom edge of the scarf using Napa Red on a no. 2 flat shader. Intensify the shadows to separate the various areas of the scarf with just a hint of Midnite Green along the very edge of your no. 2 flat shader. Use a liner to highlight the scarf in forward areas with Titanium (Snow) White.

Float a little line of Midnite Green just under the upper eyelash line to create a shadow on the eyeball cast by the upper eyelid. Intensify the upper lash line with more Charcoal Grey. Add small eyelashes just at the outside half of each eye. Increase the brightness of the face by adding more touches of Titanium (Snow) White on both eyes just above and below the iris of each eye, using a fine liner. Add more Titanium (Snow) White on the cheeks and across the top of the carrot nose by using a small, flat shader. Lightly float Brandy Wine down either side of the carrot nose to shade it. Add a slight Titanium (Snow) White highlight down the center of the carrot. Blush the cheeks and lower lip with just a hint of Brandy Wine. Then add a Titanium (Snow) White shine dot on each cheek.

"Snowman's Gingham & Garlands"

BARBARA NEILSEN

MEDIUM: *Acrylics, Pen & Ink*

COLORS: **Delta Ceramcoat:** *Christmas Green • Ocean Reef Blue • Liberty Blue • Golden Brown • Midnight Blue • Mendocino Red • Yellow • White* **DecoArt Americana:** *Cadmium Red*

BRUSHES: **Loew-Cornell:** *Series 7000 no. 3 round • Series 7000 no. 5 round • Series 7300 no. 10 flat • Series 7350 no. 0 liner • Series 7400 ¼-inch (6mm) angular shader • Series 7400 ½-inch (13mm) angular shader • small, old scruffy brush*

OTHER SUPPLIES: *Rotring Rapidoliner pen no. .25*

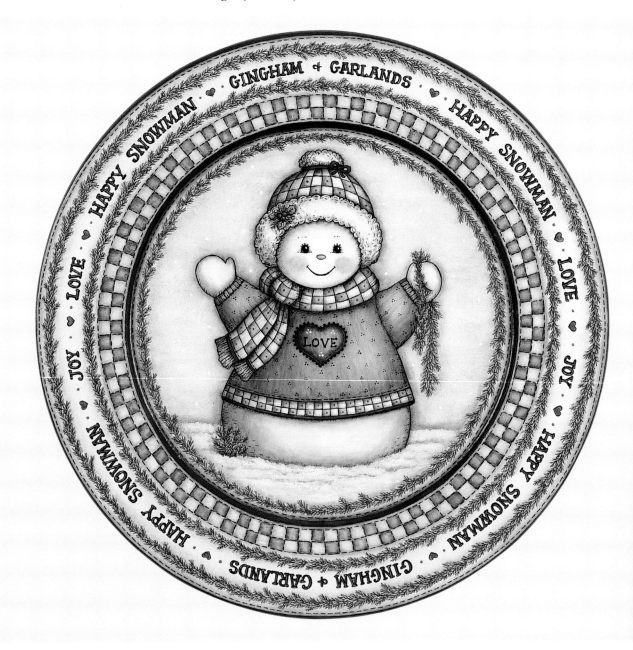

1 Ink Drawing

Use a Rotring Rapidoliner pen no. .25 to draw the snowman above.

2 Wash Basecoats

Use Christmas Green to wash in the holly leaves. Use a small round with diluted paint and stroke in the direction of the pine needles. Use a wash of Ocean Reef Blue to paint the sky. The sweater and every other check is painted with a wash of Liberty Blue. A Cadmium Red wash is used to paint the nose, cheeks, heart and line ribbon and trim. Use a wash of Golden Brown for the fringe.

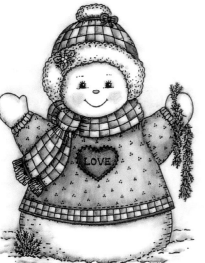

3 Float Shading

Shade snowman, hat fur, ground and every other check with Golden Brown. Use Midnight Blue to shade the sweater and blue checks. Then shade the entire checked area as a whole. Also shade snowman, hat fur and the ground. Use Mendocino Red to shade the heart, red trim and fringe.

4 Finishing Details

Deepen shadows with Midnight Blue. Add warm highlights with Yellow. Use White to pounce snow. Apply tints, dots and re-ink if necessary.

"Three of a Kind"

TRUDY BEARD

MEDIUM: *Acrylic*

COLORS: **FolkArt Artists' Pigments:** *Aqua • Warm White • Brilliant Ultramarine • Burnt Carmine • Hauser Green Dark • Napthol Crimson • Pure Black • Pure Orange*
FolkArt acrylic: *Dark Hydrangea • Fresh Foliage • Fuchsia*

BRUSHES: **Royal:** *Series 4585 no. 10/0 script • Series 4150 no. 2 shader • Series 4150 no. 4 shader • Series 4150 no. 6 shader • Series 4150 no. 8 shader • Series 4150 no. 12 shader*

OTHER SUPPLIES: *FolkArt Blending Gel • light gray transfer paper • stylus*

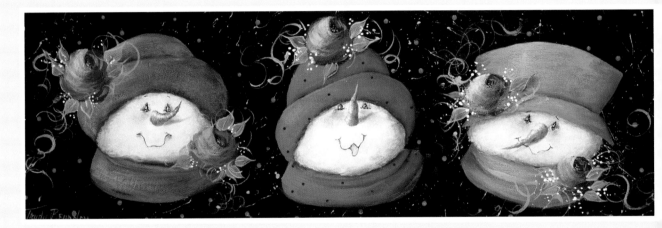

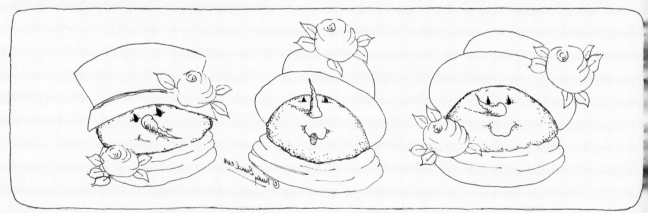

1 Line Drawing
This line drawing may be hand-traced or photocopied for personal use only.
Enlarge at 119% to bring it up to full size.

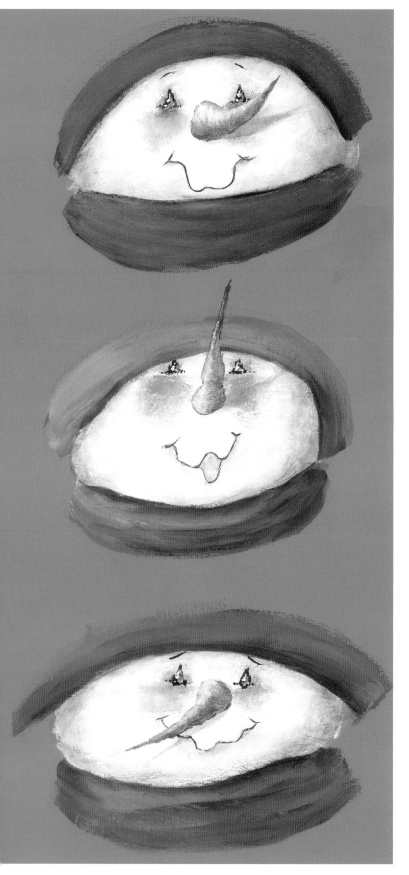

2 Face

Paint the entire face with Warm White. Allow to dry. Transfer the features (eyes, carrot nose and mouth lines) with light gray transfer paper.

Load the no. 12 brush with a small amount of Blending Gel; blot. Next, load the brush with Warm White and repaint the face, avoiding the features. While this application of paint is still moist, load the brush with a small amount of Blending Gel, then a brush mix of Warm White, a touch of Brilliant Ultramarine and a bit of Aqua. (To brush mix, load the brush with one color, then another. Blend a couple of times on the palette. Then apply color.) Dab in the shading where indicated with the corner and flat side of the brush. Dry wipe the brush. Pick up Warm White to soften any hard edges of shading by pat-blending Warm White into the edges of the shadow color. Add more shading if needed.

3 Blush

Before painting blush, re-wet the area to be painted. Load the no. 8 brush with Blending Gel, blot, then load with Warm White. Paint the blush area. While this is moist, pick up a small amount of Fuchsia and Warm White and lightly brush on blush, starting under the eyes. After this dries, you may want to add a bit more color right under each eye.

Three of a Kind

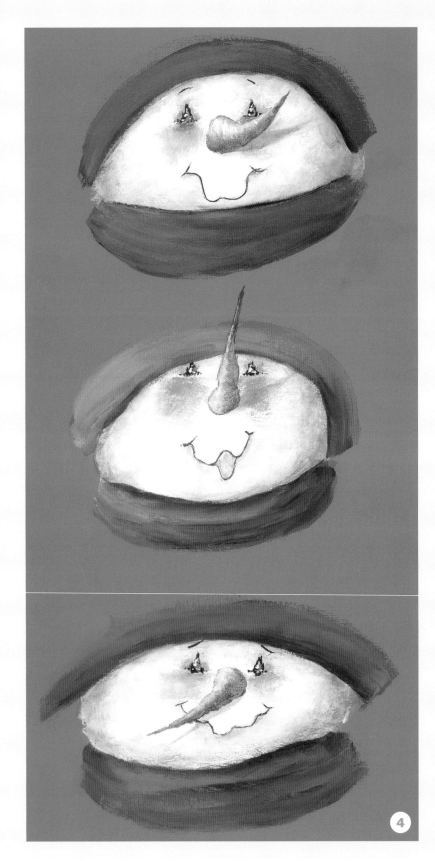

4 Eyes, Mouth & Eyebrows

Paint the eyes using Pure Black on a no. 2 or 4 brush. Use a no. 10/0 script to paint a bit of Brilliant Ultramarine and Warm White on the right and lower side of each eye. This is called accent color or is also referred to as reflected light. Dip the tip of the 10/0 script into a puddle of Warm White and dab a highlight on each eye. Note that the strongest and largest highlight is on the left side of each eye. Add a tiny dot of Warm White to the lower right corner.

The mouth and eyebrows are painted Pure Black that is thinned with water, using the no. 10/0 script.

Right-Facing Nose

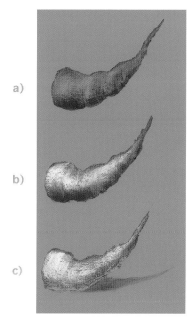

a)

b)

c)

5 Carrot Nose

a) Use a no. 4 or 6 shader to paint the carrot with Pure Orange. Pick up a bit of Burnt Carmine on the same brush and stroke in shading along the lower edge of the carrot. Note the slight curve of the strokes; this will create contour. Clean the brush and squeeze dry.

b) Load the same brush with a brush mix of Warm White and Pure Orange; apply highlight. Again, note the slight curve of the strokes when applying color.

c) Add more highlight by stroking on more Warm White with the same brush. Add a reflected light along the lower edge of the carrot by applying a scant amount of Warm White and Brilliant Ultramarine. Paint a cast shadow next to the nose by loading a no. 6 flat with Blending Gel, then a small amount of Brilliant Ultramarine and a tiny speck of Pure Black. Test on your palette to make sure the color is light and transparent. Add more Blending Gel, if needed, to make the color more transparent.

Left-Facing Nose

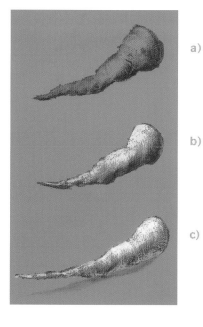

a)

b)

c)

Upward-Facing Nose

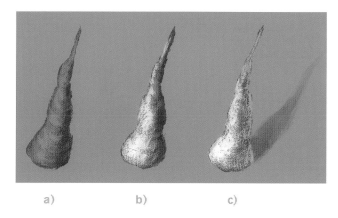

a) b) c)

TAKE NOTE

Regardless of the direction of the nose, all noses are painted the same (see above steps).

Three of a Kind

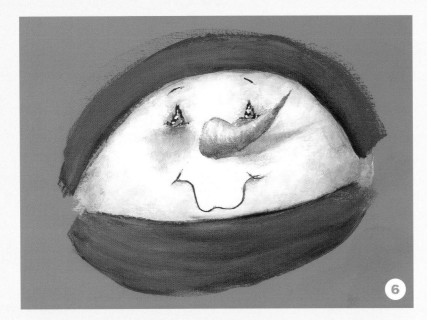

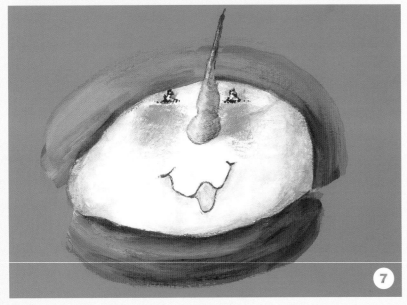

6 Pink Hat & Muffler

Use the no. 12 and 8 brushes and a brush mix of Fuchsia and Warm White to paint the hat and muffler. Allow to dry. Repaint by picking up Blending Gel. Blot, then load with the same color mix as before. While this layer is still moist, pick up a corner load of Burnt Carmine and apply shading. Use a no. 8 to brush mix Brilliant Ultramarine and Warm White; dry brush this mixture on shadows. Add a bit of highlight to hat and muffler by dry brushing a scant amount of Warm White and Fuchsia.

7 Blue Hat & Muffler

Use a no. 8 and Dark Hydrangea to paint the hat and muffler. Allow to dry, then apply a second coat. Apply shading with a no. 8 loaded with Blending Gel. Blot, then load with Dark Hydrangea and a corner load of Brilliant Ultramarine. Clean brush in water then squeeze dry. Highlight hat and muffler with a brush mix of Dark Hydrangea and Warm White. Accent the shadows with a scant brush mix of Fuchsia and Warm White.

8 Aqua Hat & Muffler

Use the no. 12 and 8 brushes and Aqua to paint the hat and muffler. Apply two coats, allowing the first to dry before applying a second coat. Load the no. 12 or 8 brushes with Blending Gel; blot, then load with Aqua and a corner load of Hauser Green Dark to apply shading. Clean brush in water then squeeze dry. Highlight the hat and muffler with a brush mix of Aqua and Warm White. Accent the shadows with a scant brush mix of Brilliant Ultramarine and Warm White.

9 Roses & Leaves

Use a no. 6 to block in the rose shape with Napthol Crimson. Load the same brush with Blending Gel. Blot, pick up Napthol Crimson and Burnt Carmine. Shade the center "cup" shape and the right side. Clean brush and squeeze dry. Load the no. 6 with a mix of Fuchsia and Warm White; blot. Use this color mix to dry brush across the rose shape, starting on the left side. Highlight by dry-brushing with a slightly lighter value of the same color mix. Add a few tiny dots in the center with Fresh Foliage on the tip of the no. 10/0 script.

To paint the leaves, load a no. 6 with Hauser Green Dark and stroke on a few leaves. Dry wipe the brush, pick up Fresh Foliage and stroke lightly on top of each leaf. Clean brush in water and squeeze dry. Add a small amount of Fuchsia and Warm White to most leaves by lightly stroking on color with the no. 6. Use the no. 10/0 script, Fresh Foliage and a little Warm White to loosely outline and add center veins.

Pour a fresh puddle of Warm White onto your palette. Dip the tip of a stylus into the paint and dot filler flowers around each rose.

"Wintertime Friends"

PAM GRADY

MEDIUM: *Acrylic*

COLORS: **DecoArt Americana:** *Neutral Grey • Light Buttermilk • Dark Chocolate • Red Iron Oxide • Lamp (Ebony) Black • Jack-O-Lantern Orange*

BRUSHES: **Loew-Cornell:** *¼-inch (6mm) deerfoot • ¼-inch (6mm) angular • no. 10/0 liner*

OTHER SUPPLIES: *stylus*

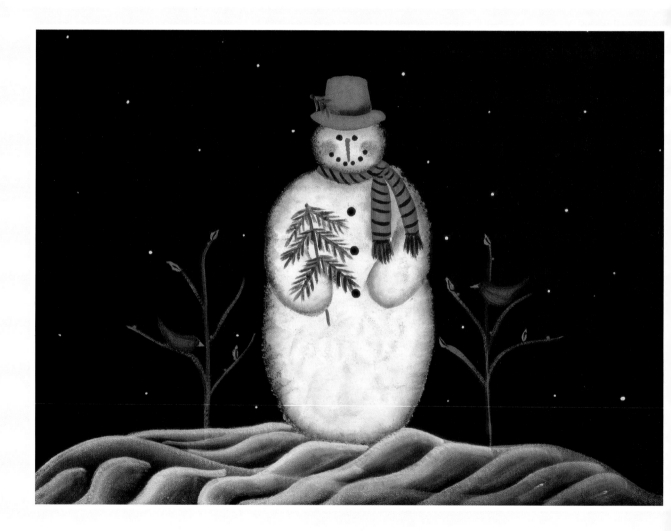

SNOWMAN'S FACE

1 Stipple the Shape

Stipple the face area using a ¼-inch (6mm) deerfoot brush and Neutral Grey.

2 Stipple Again

Let dry and repeat using Light Buttermilk.

3 Facial Features

Float around the face using a ¼-inch (6mm) angular brush and Dark Chocolate. Stipple the cheeks with a ¼-inch (6mm) deerfoot and Red Iron Oxide. Dot the eyes and mouth with a stylus and Lamp (Ebony) Black. Use a no. 10/0 liner brush and Red Iron Oxide to make the nose.

4 Finishing Details

Repeat stipple on face, if needed, using the ¼-inch (6mm) deerfoot and Light Buttermilk. Repeat float around the face using a ¼-inch (6mm) angular brush and Dark Chocolate. Dot the highlight on the nose by using a stylus and Jack-O-Lantern Orange.

"This Little Light"

PHYLLIS TILFORD

MEDIUM: *Acrylic*

COLORS: **Delta Ceramcoat:** *Black • Black Cherry • Chocolate Cherry • Dark Burnt Umber • Georgia Clay • Hammered Iron • Mudstone • Sandstone • Lemon Grass • Spice Brown • Straw • Timberline Green • White*

BRUSHES: **Loew-Cornell:** *Comfort Series no. 2 filbert • Comfort Series no. 4 filbert • Comfort Series no. 8 filbe • Comfort Series no. 10 filbert • Jackie Shaw Series no. 1 JS liner*

OTHER SUPPLIES: *J.W. etc.'s Open Time Extender/Retarder*

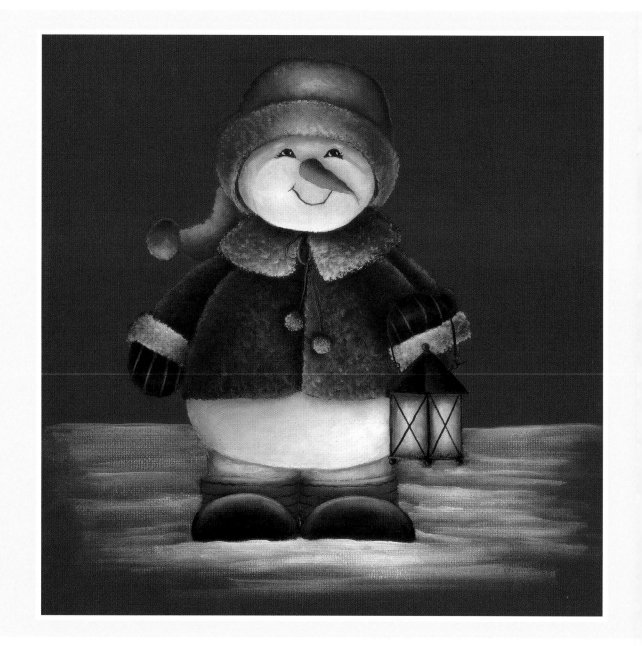

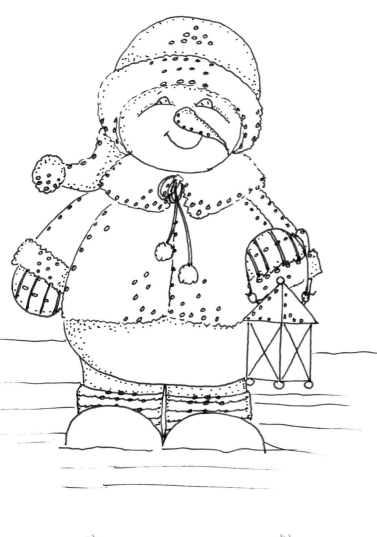

1 Line Drawing

This line drawing may be hand-traced or photocopied for personal use only. Enlarge at 147% to bring it up to full size. Unless directions are given in the written instructions, shaded areas are marked with dots and highlighted areas with ooo's on the line drawing.

2 Ground Snow

a) Float the snow using a fairly wet no. 10 filbert, side loaded with Sandstone. Begin at the top of the ground area and paint with a horizontal motion, using the front and back of the brush and walking the color down toward the bottom. The color should be on the top side of the brush. Let dry.

b) Use White for the highlight floats, starting at the top and walking the color down to the foreground.

c) Apply a smooth coat of extender on the ground area, using a large, soft brush. Brush over the area again to remove any excess medium. Blot the no. 10 filbert heavily on a dry paper towel to remove any moisture. Side load the no. 10 filbert into White and apply more highlights where desired. The extender will allow a good amount of working and blending time, but be sure to leave some shadows in the area. Position the brush so that the paint side is where the color is desired, with the clean side of the brush on the area where paint is not desired. Don't overwork the area as it begins to dry—simply allow it to dry, apply more extender and continue till the desired highlights are achieved. Mop to soften any hard color lines.

a)

b)

c)

2

This Little Light

a) b)

c) d)

a) b)

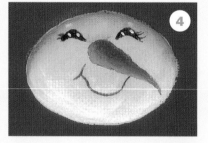

c) d)

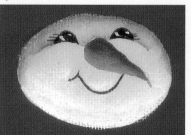

3 Head & Body

Use the no. 10 filbert for basecoating, shading and highlighting. Base with Sandstone.

a) The first shading is Mudstone.

b) Repeat the shading in the same areas with transparent Spice Brown and Hammered Iron.

c) Highlight with White. The lantern is the light source and all areas that face it will be brightest. Begin on the right and walk the brush back and forth toward the center area on the face and body.

d) Apply extender as instructed in step 2C. Add further highlights reflecting from the lantern with the no. 10 filbert and White. Mop to soften.

4 Face Features

a) To paint the eyes and mouth, use the line brush with Dark Burnt Umber.

b) Add a highlight on the lower left side of the eyes and a smaller highlight on the upper right side with White on the tip of the liner. To paint the nose, base in Georgia Clay on the no. 2 filbert. Highlight the lower edge of the nose using Georgia Clay and Straw.

c) With the no. 4 filbert, float Mudstone above the cheeks and around the eyes. Shade the upper edge of the nose with Spice Brown.

d) Highlight the top of the cheeks and the forehead with White on the no. 8 filbert. For the nose, repeat the shading in the same area with Dark Burnt Umber.

a)

b)

c)

d)

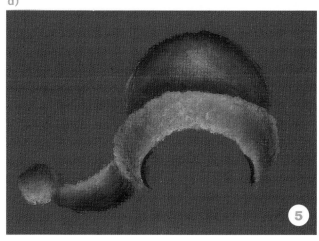

TAKE NOTE

All highlighted areas on clothing are painted with the light source coming from the lantern. While the highlight might be on top of one object (such as the shoe), as the light moves toward the face it would reflect more on the bottom of that object (like the collar).

The "furry" look is achieved by using a side-loaded filbert brush with a patting motion. Build the highlight colors gradually. Extender will be used during the last step for the final highlights on all furry clothing. Keep the paint side of the brush on the area where more color is wanted, walking and patting it back toward, but not into, the shaded area. As long as the clean side of the brush is directed toward the shaded areas, they will remain darker.

5 Hat

a) Pat on Timberline with the no. 4 filbert, keeping the edges fuzzy.

b) Shade all areas with floated color, using Timberline and a touch of Dark Burnt Umber. Use the liner with the same shading colors for the inside of the hat around the cheek areas.

c) Side load the no. 4 filbert into Timberline, blend and side load the same side into a bit of Lemon Grass. Blend again and begin patting on highlights. Start in the brightest areas and walk the brush back toward the shaded areas.

d) Apply extender as instructed in step 2C. Emphasize the final highlights with Lemon Grass and a touch of White. Mop to soften.

This Little Light

a) b) c)

a) b)

c) d)

a) b)

6 Jacket, Fur Collar & Cuffs

a) To paint the jacket, pat on Black Cherry with the no. 8 filbert, keeping the edges fuzzy. For the fur collar and cuffs, pat on Dark Burnt Umber with the no. 4 filbert, again keeping the edges fuzzy to simulate fur.

b) Begin the highlights on the jacket with a soft side-loaded blend of Black Cherry and Sandstone. Keep this light color out of the dark areas, as there is no shading on the jacket. The base color becomes the shaded area. Add highlights to the fur objects by patting on Dark Burnt Umber and Sandstone.

c) Apply extender to the jacket. Emphasize the final highlights with a side-loaded blend of Black Cherry, Sandstone and White. Also apply extender to the fur. Emphasize the lighter areas with Dark Burnt Umber, Sandstone and White.

7 Mittens

a) Paint the mittens Chocolate Cherry, using the no. 4 filbert. Highlight with Chocolate Cherry and a touch of Sandstone.

b) Paint the stripes with thinned Timberline, using the liner brush.

c) Highlight the center of the stripes with Timberline and Lemon Grass.

d) Shade along the top and bottom of the mittens with Chocolate Cherry.

8 Ties & Tassels

a) Paint the ties with Black Cherry on the liner. Highlight with this dirty brush and Sandstone while the surface is still wet.

b) Paint the tassels with the same color as used for fur (see step 6A), using the no. 2 filbert. Float a shadow behind the left side of each tassel with Black Cherry and a touch of Chocolate Cherry, using the no. 4 filbert.

a)

b)

d)

9

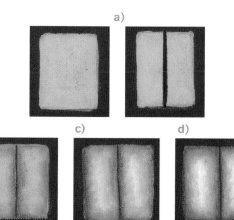

b)

10

a)

b) c) d)

e) f)

11

9 Stockings

a) and b) Basecoat with Timberline, using the no. 2 filbert. All shading and highlighting are the same as for the hat (see step 5), but applied as floated color.

c) Stripes are painted with the liner and Black Cherry.

d) Highlight the center of the upper stripes with this dirty brush and Sandstone while the surface is still wet.

10 Shoes

a) Paint the shoes Dark Burnt Umber, using the no. 4 filbert. Highlight the upper areas with Dark Burnt Umber and Sandstone.

b) Shade along the soles with Black.

11 Lantern

a) Paint the light section with Straw on the no. 2 filbert. Separate the two panels with thinned Black.

b) Shade around each panel with a heavy float of Spice Brown.

c) Highlight the center areas with Straw and White, using back-to-back floats.

d) Apply extender and reinforce the highlight with less Straw and more White.

e) Paint the remainder of the lantern with Black, using the no. 2 filbert for flat areas and the liner for line work and decorations.

f) Finally, highlight with Black and a touch of Sandstone.

"Sparkles"

TRUDY BEARD

MEDIUM: *Acrylic*

COLORS: **FolkArt Artists' Pigment:** *Aqua • Yellow Citron • Brilliant Ultramarine • Burnt Carmine • Hauser Green Dark • Pure Black • Pure Orange • Warm White •* **FolkArt acrylic:** *Fuchsia • Lavender • Vivid Violet •* **FolkArt Metallic:** *Amethyst*

BRUSHES: **Royal:** *Series 4585 no. 10/0 script • Series 4150 no. 2 shader • Series 4150 no. 4 shader • Series 4150 no. 6 shader • Series 4150 no. 8 shader • Series 4150 no. 12 shader • Series 4700 ¹/₂-inch (13mm) shader*

OTHER SUPPLIES: *FolkArt Blending Gel • transfer paper • stylus • varnish*

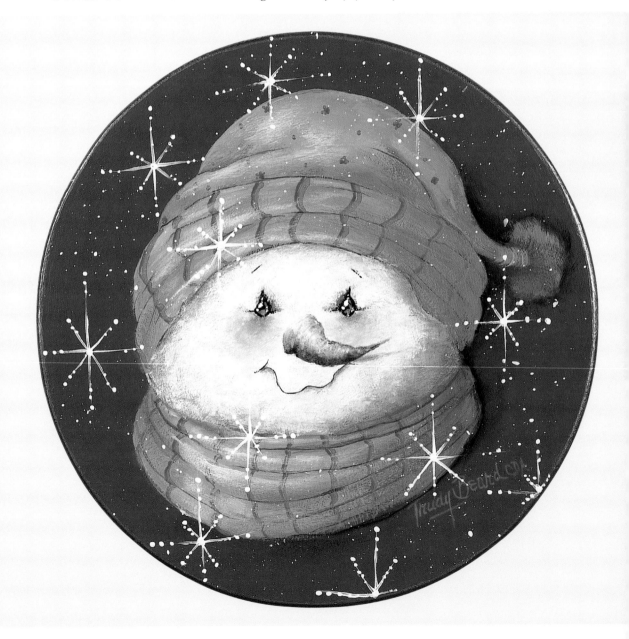

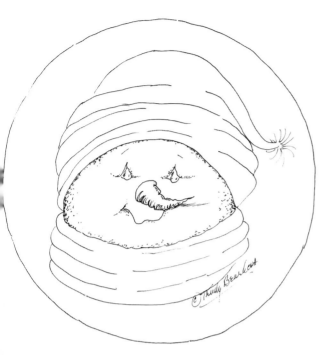

1 Line Drawing

This line drawing may be hand-traced or photocopied for personal use only. Enlarge at 106% to bring it up to full size.

2 Face & Facial Features

Transfer the line drawing with white transfer paper. Do not transfer the features yet. Paint the entire face with Warm White; allow to dry. Transfer the features (eyes, carrot nose, mouth line) with light gray transfer paper. Load the no. 12 shader with a small amount of blending gel; blot. Load the brush with Warm White and repaint the face, avoiding the features. While this paint is still moist, load the brush with a small amount of blending gel, then a brush mix of Warm White, a touch of Brilliant Ultramarine and a bit of Aqua. Dab in the shading where indicated with the corner and flat side of the brush. Dry wipe the brush, pick up Warm White and soften any hard edges of shading by pat-blending Warm White into the shadow edges. Add more shading if needed, or add more after the features are painted.

To paint the mouth and eyebrows, use a no. 10/0 script and Pure Black thinned with water.

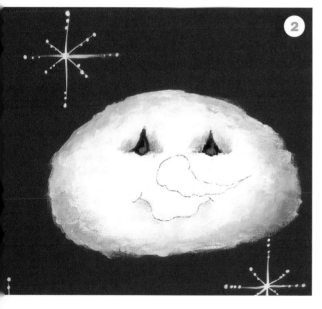

TAKE NOTE

"Sparkles" was painted on a round metal box, but can be painted on any surface. The background is basecoated with two coats of Vivid Violet. The stripe around the edge is Yellow Citron. The next stripe is Amethyst. On either side of the Yellow Citron stripe and the Amethyst stripe, add a thin stripe of Aqua.

Sparkles

a)

b)

c)

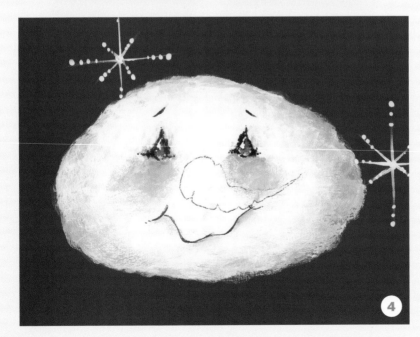

3 Eyes

a) Paint the eyes Pure Black with a no. 2 or 4 brush. Use a no. 10/0 script to paint a bit of Brilliant Ultramarine and Warm White on the right and lower side of each eye.

b) Dip the tip of the 10/0 script into a puddle of Warm White and dab a highlight on each eye. Note that the largest highlight is on the left side of each eye. There is a tiny dot of Warm White on the lower right side of each eye. The highlight on the left of each eye is irregular (no round dots here). Start with the large area, then create smaller dabs extending out from the starting point. This will create a bright and shiny light in the eyes.

c) Brush mix Warm White and a bit of Brilliant Ultramarine with the script brush. Add a lighter blue accent at the bottom center of each eye. This extra reflected light adds a little more sparkle to the eyes.

4 Blush

Before painting blush, re-wet the area to be painted. Load the no. 8 with blending gel. Blot, then load with Warm White. Paint the blush area. While this is moist, pick up a small amount of Fuchsia and Warm White and lightly brush on blush, starting under the eyes. After this dries, you may want to add a bit more color right under each eye.

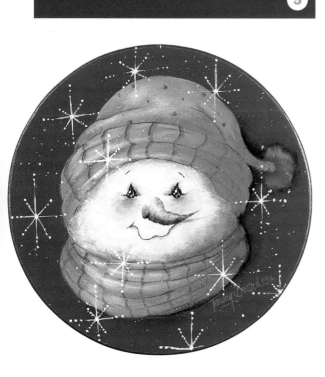

5 Carrot Nose

a) Use the no. 6 brush and Pure Orange to paint the carrot nose. Pick up a tiny bit of Burnt Carmine on the same brush and stroke in shading along the lower edge of the carrot. Clean brush and squeeze dry.

b) Load the same brush with Warm White and a bit of Pure Orange to apply the highlight. Note the slight curve of the strokes on the carrot—a slight curve to the left creates contour.

c) Add more highlight by stroking on more Warm White with the no. 6. Add a reflected light along the lower edge of the carrot by applying a scant amount of Warm White and Brilliant Ultramarine.

6 Hat & Muffler

Use the no. 12 and Yellow Citron to paint the hat and muffler. Allow to dry. Repaint them by loading the brush with a bit of blending gel, blot, then load with Yellow Citron. The paint will stay moist for a few minutes. Load the brush with Yellow Citron again, then tip the corner of the brush into Hauser Green Dark. Blend a few times on your palette, then paint shadows and creases in the hat and muffler. When the shadows are dry, pick up a bit of Warm White and Yellow Citron and pat highlights where indicated. Paint Lavender, then Aqua stripes with the no. 10/0 script. Look at the photograph—note that the stripes are slightly curved to create the illusion of folds. Create an accent of blue on the shadows of both the hat and muffler by dry brushing on a small amount of Brilliant Ultramarine and Warm White.

7 Snowflakes

Complete the painting, allow it to dry thoroughly, then varnish before adding the snowflakes. They are easier to clean up this way. Pour a fresh puddle of Warm White on your palette. Dip the tip of the stylus into the puddle, then dab on a large dot that will be the snowflake center. While the dot is still moist, use the no. 10/0 script to pull out thin streaks from the center dot. Now use the smaller end of the stylus and dot in the small dots. Start on the outer tip and dot toward the center without loading more paint. After the snowflakes dry (remember, this will take longer because of the dots) varnish again.

"Touched by a Snowflake"

PHYLLIS TILFORD

MEDIUM: *Acrylic*

COLORS: **Delta Ceramcoat:** *Barn Red • Blue Wisp • Calypso Orange • Dark Burnt Umber • Dark Forest G* *Georgia Clay • Mudstone • Raw Linen • Spice Brown • Spice Tan • White*

BRUSHES: **Loew-Cornell:** *Jackie Shaw Series no. 1 JS liner • Series 3500 no. 2 filbert • Series 3500 no. 4 fil* *• Series 3500 no. 8 filbert*

OTHER SUPPLIES: *Delta Int/Ext Varnish, matte finish • stylus*

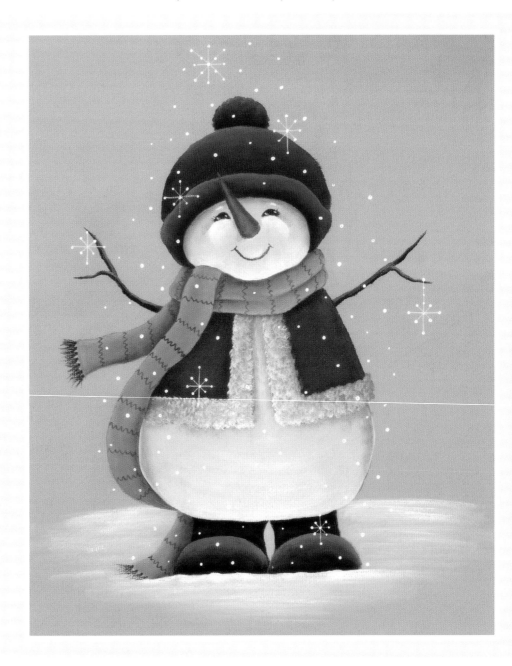

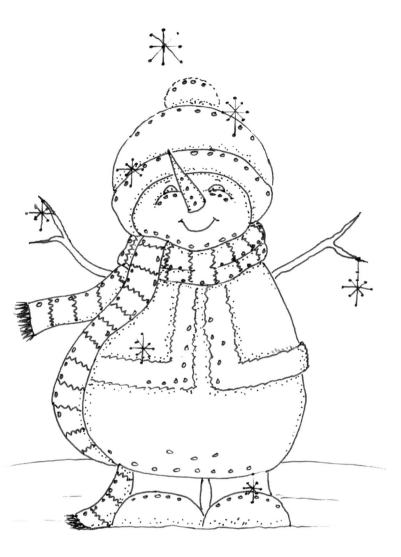

1 Line Drawing
This line drawing may be hand-traced or photocopied for personal use only. Enlarge at 161% to bring it up to full size. Unless other directions are given in the written instructions, shaded areas are marked with dots and highlighted areas with ooo's.

TAKE NOTE

Filberts are used for this technique. They hold a lot of water and create a very soft float of color. Wet the brush and blot very lightly on a soft paper towel. Load just one corner of the brush with paint and blend thoroughly on the palette. Allow the paint and water to blend through the bristles by using heavy pressure on the strokes. But don't let the paint spread to the other side of the brush. Do not twist the hairs of the brush while blending or stroking on the surface. When the proper amount of paint has been blended (the blended stroke is a smooth gradation of color on one side and fades to nothing on the other side), it is ready to be placed on the surface. Use a pat-and-pull motion for this.

If two colors are noted for floating, simply load the first color on the side of the brush, blend on the palette, then load the second color on the same side of the brush and blend again.

All shading and highlighting is floated color, unless otherwise noted.

Touched by a Snowflake

a) b) c)

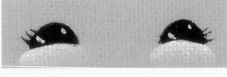

2 Face, Body & Hat

a) On the face and body: Use the no. 8 filbert to base with Raw Linen. Allow to dry. Paint the hat Dark Forest Green, using the no. 4 and no. 8 filberts. Shade under the hat, around the outer edges of the face and on the outer edges of the body with Mudstone on the no. 8 filbert. Allow to dry.

b) On the face and body: Use the no. 8 filbert to repeat shading with Spice Brown. All colors are blended on the palette to a transparent consistency. Highlight the hat. While the last basecoat application is still wet, use the same dirty brush and side load one side into Calypso Orange. Using heavy pressure, pat and blend this color on all highlight areas marked with ooo's on the line drawing.

c) On the face and body: Highlight with White, using the no. 8 filbert on the cheek areas, chin, lower face and along the bottom of the body. Walk this up toward, but not into, the shaded areas on the bottom with a fairly wet brush. Shade the hat with Dark Forest Green and a touch of Dark Burnt Umber, side loaded on the same side of the brush.

3 Eyes & Mouth

a) Using the liner, paint in the eyes with Dark Burnt Umber. Use a small filbert with White to float cheeks under the eyes.

b) Pull tiny eyelashes out of the corner of each eye with the liner.

c) Add a highlight on each lower left side and a smaller highlight on each upper right side with White on the brush tip of the liner.

d) Apply a tiny White stroke over the eyes for eyebrows.

e) To paint the mouth line, thin Dark Burnt Umber with water and blend well

a) b) c)

4 Carrot Nose

a) Paint the nose with Georgia Clay on the no. 2 filbert.

b) Highlight the center of the carrot with Calypso Orange.

c) Shade the upper and lower edge with Spice Brown.

a) b)

5 Twig Arms

a) Basecoat with Dark Burnt Umber, using the liner.

b) Add a touch of Raw Linen to the dirty brush; stroke the upper edges for highlights.

a) b)

6 Vest & Fur Trim

a) Basecoat the entire vest, including the fur area, with Georgia Clay on the no. 8 filbert. Transfer the fur area. Shade with Barn Red on the no. 8 filbert.

b) Using the side-loaded no. 2 filbert, pat on Mudstone. Keep the tip of the brush directed into the outside edges for a furry look.

c) d)

c) Highlight the fur by side loading the Mudstone side into White. Lightly pat on highlights again, keeping the edges fuzzy.

d) Repeat the highlights, bringing the light area toward the center with more White on this dirty brush. Shade under the fur where the scarf will be painted and on each side with transparent floats of Spice Brown.

Touched by a Snowflake

a) b) c)

d) e) f)

a) b)

7 Scarf

a) Basecoat with Spice Tan, using the no. 4 filbert. Highlight with Spice Tan and Calypso Orange.

b) Shade with Spice Brown.

c) Repeat shading with an extremely transparent float of Barn Red.

d) Zigzag stripes are painted using Dark Forest Green on the liner.

e) Paint the knots with Dark Forest Green and a touch of Dark Burnt Umber. Paint the fringe using the liner, with a brush mix of Dark Forest Green and a touch of Dark Burnt Umber, thinned to an inky consistency.

f) Overstroke the fringe with the dirty brush and Calypso Orange.

8 Boots

a) Basecoat with Dark Burnt Umber, using the no. 4 and no. 8 filberts. Base in the scarf with Spice Tan and shade with Spice Brown.

b) Highlight the tops of the toe area with Dark Burnt Umber and Blue Wisp.

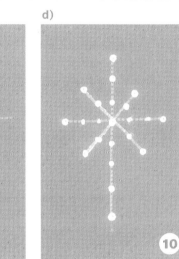

9 Ground Snow

Float on the ground snow using a fairly wet no. 8 filbert with Raw Linen. Begin at the top of the ground area and paint with a horizontal motion, moving down toward the bottom. Allow to dry. Repeat the floats using White for highlights.

10 Snowflakes

a) Thin White paint with water to create an inky consistency. Use the liner to paint a very thin vertical line first.

b) Paint the center horizontal line.

c) Paint the intersecting lines.

d) Use the small end of the stylus and uniformly apply dots on all tips of the lines and in the center of each snowflake.

O FINISH

dd dots of snow on the project using the
rge tip of the stylus, or spatter using an
ld, soft toothbrush.

Remove any remaining transfer lines
ith a dampened sponge or wet brush.

Finish the project by applying 3–4
oats of varnish.

"Snowman & Friend"

JUDY DIEPHOUSE

MEDIUM: *Acrylic*

COLORS: **Delta Ceramcoat:** *Blue Storm • Mediterranean Blue • Paradise Blue • Purple Smoke • White • Blue Mist • Poppy Orange • Black Cherry • Pumpkin • Black • Rouge • Christmas Green • Dark Foliage Green • Spring Green • Bright Red • Perfect Highlight for Red • Perfect Highlight for Green • Blue Velvet • Straw*

BRUSHES: **Loew-Cornell:** *Jackie Shaw Series no. 1 JS liner • Series 7300 no. 4 flat • Series 7300 no. 8 flat • Series 7300 no. 12 flat • Series 7550 1-inch (25mm) flat • Series 7850 ¼-inch (6mm) deerfo* • *Series 7850 ½-inch (13mm) deerfoot • no. 10/0 liner*

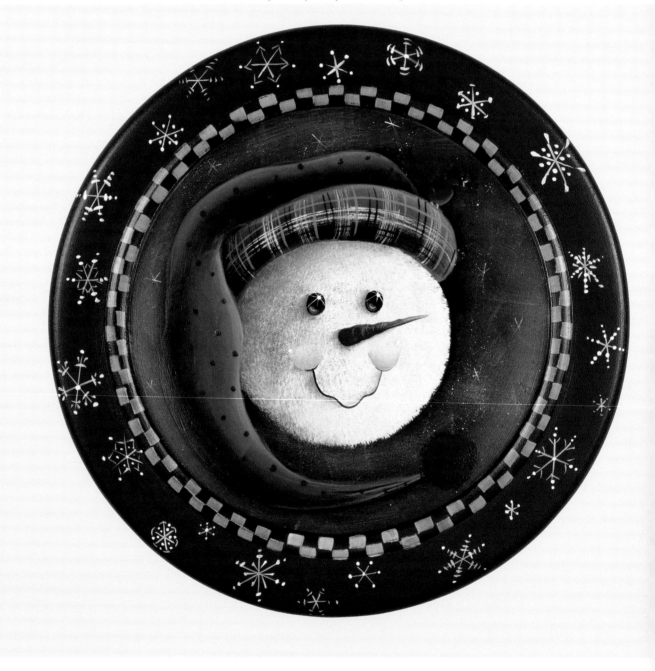

1 Line Drawing

This line drawing may be hand-traced or photocopied for personal use only. Enlarge at 147% to bring it up to full size.

2 Background

Basecoat with Blue Storm. Let dry and then transfer the line drawing. In the center, drybrush some highlights around the snowman with Mediterranean Blue on a 1-inch (25mm) flat. Repeat the dry-brush highlights with Paradise Blue. Spatter the center area with White.

Snowman & Friend

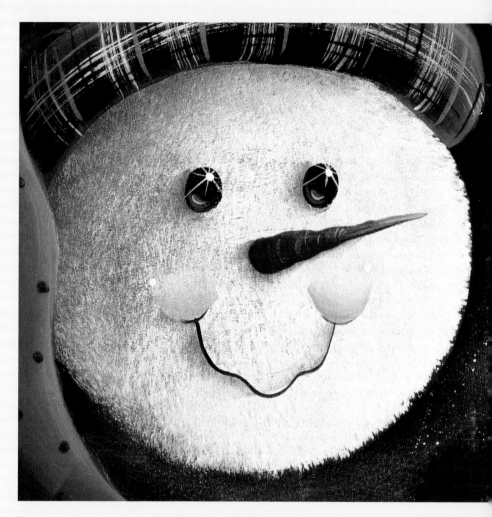

3 Snowman Head

Basecoat the face with Purple Smoke. Use the ¹/₂-inch (13mm) deerfoot to stipple the highlight from the right side, fading out to the left with Blue Mist. Highlight again with White.

4 Facial Features

Basecoat the nose with Poppy Orange, using a no. 4 flat. Shade where it connects to the face and along the bottom edge of the nose with Black Cherry. Highlight from the tip and along the top edge with Pumpkin, using a JS no. 1 liner.

Basecoat the eyes with Black, using a no. 4 flat. Highlight the eyes in the lower left side with a side-load flat "C" stroke of Mediterranean Blue. Repeat with a smaller side-load "C" stroke of Paradise Blue. Add a dot of White in the upper right side of the eye. Intersect the dot with fine shine lines of White on a no. 10/0 liner. Repeat the dot on top of the lines.

The cheeks are a side-load float of a mix of Rouge and White (1:1), using a no. 12 flat.

Using the no. 12 flat, shade the left side of the eyes, carrot nose and mouth lines with a side-load float of Purple Smoke.

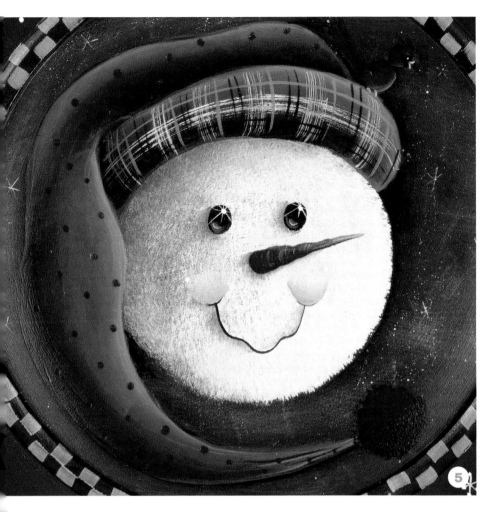

Hat

Basecoat the hat with Christmas Green. Shade the left side of the bird's tail, above the band, the lower edge of the band and where the bird's tail crosses over the band with a side-load float of Dark Foliage Green on a no. 12 flat. Highlight the right side of the tail, the upper edge of the hat and the upper edge of the band with a side-load float of Spring Green.

For the plaid on the hatband—the broad stripe is White, using a ¼-inch (6mm) deerfoot. The two thin stripes to the left and below the White stripe are Bright Red, using a no. 1 liner. The green stripe to the right and above the White is Spring Green.

The dots on the rest of the hat are Bright Red, using the round end of a liner brush.

Shade the hat again with Dark Foliage Green. Highlight the hat again with Perfect Highlight for Green.

The pom-pom on the end of the hat is stippled with Bright Red, shaded with Black Cherry and highlighted with Perfect Highlight for Red, using a ¼-inch (6mm) deerfoot.

Shade the face next to the hat with a soft side-load float of Purple Smoke, using a no. 12 flat.

Snowman & Friend

6 Cardinal

The cardinal is basecoated with Bright Red, using a no. 4 flat. Shade the top of the back and the back of the head with Black Cherry. Highlight the stomach and face with a side-load float of a brush mix of Bright Red and a touch of White on a no. 4 flat. Tip the tail feathers, the wing strokes and the tuft on top of the head with Perfect Highlight for Red, using a no. 1 liner. Using a no. 10/0 liner, add fine lines of Black for the face area. The eye is a tiny dot of White. The beak and feet are fine lines of Straw.

7 Final Details

Shade around the snowman's face and hat with a side-load float of Blue Velvet, using a no. 12 flat.

The checks are a brush mix of Spring Green and a touch of White, using a no. 8 flat.

The snowflakes are White, using a no. 10/0 liner and a stylus or the end of a brush.

Allow the painting to dry thoroughly. Erase any visible tracing lines. Varnish with three coats of your favorite acrylic varnish.

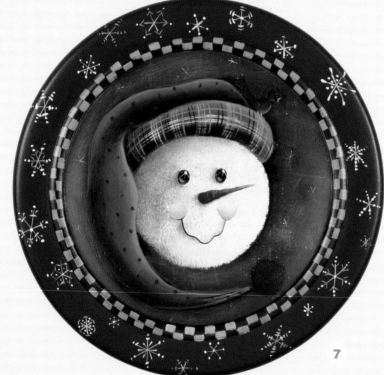

Painting a Snowman Face

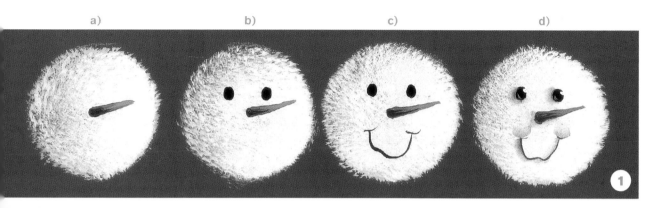

a) b) c) d)

)

b)

)

d)

1 Four Basic Steps to a Snowman Face

a) Start the wide end of the carrot nose in the center of the face. Slant the nose slightly up for a happier expression.

b) Paint the two eyes so that they are equal distance from the beginning of the nose.

c) Start the mouth line under one eye and end it under the other eye.

d) Add a soft side-load float of a pink for the cheeks. Have a side-load float of the snowman's shade color on one side of all the features—eyes, nose and mouth line.

2 Variations of a Basic Face

a) To have the snowman looking right, move the nose, eyes and mouth line slightly over to the right side of the face. The shadows are always then on the left side of the features.

b) To have the snowman looking left, move the nose, eyes and mouth line slightly over to the left side of the face. The shadows are always then on the right side of the features.

c) To have the the snowman looking up, have the nose slanting up more and have the highlights on the eyes at the top. The shadows should then be under the features.

d) To have the snowman looking down, have the nose slant down and the highlights on the eyes at the bottom. The shadows should then be above the features.

"Snug as a Bug"

PHYLLIS TILFORD

MEDIUM: *Acrylic*

COLORS: **Delta Ceramcoat:** *Barn Red • Blue Storm • Blue Wisp • Chocolate Cherry • Dark Burnt Umber • Georgia Clay • Moroccan Red • Mudstone • Olive Yellow • Raw Linen • Sea Grass • Spice Brown • Spice Tan • Timberline Green • Tuscan Red • White*

BRUSHES: **Loew-Cornell:** *Series 3500 no. 2 filbert • Series 3500 no. 6 filbert • Series 3500 no. 8 filbert • Series 3500 no. 10 filbert • Jackie Shaw Series no. 1 JS liner • Series 7350 no. 1 liner*
Tilford: *1-inch (25mm) Tilford Phylbert*

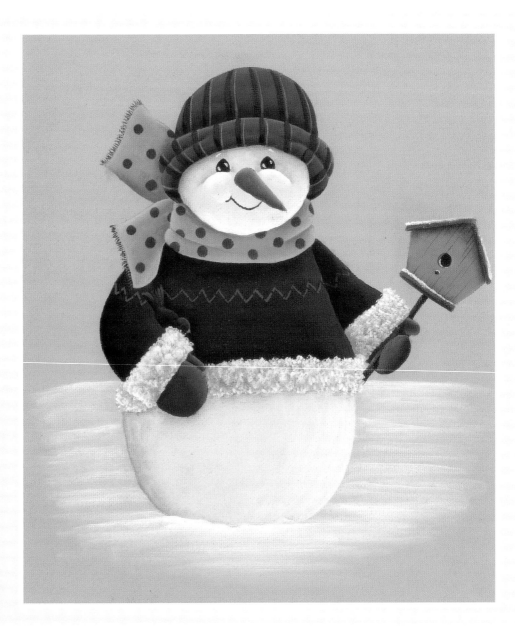

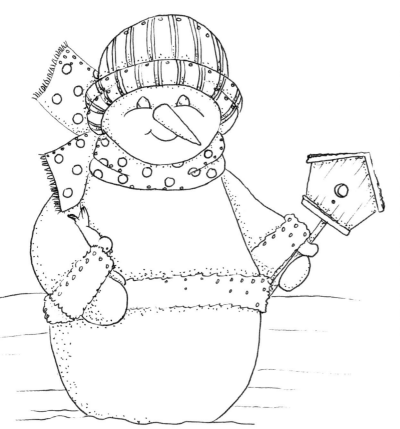

1 Line Drawing

This line drawing may be hand-traced or photocopied for personal use only. Enlarge at 185% to bring it up to full size. Shaded areas are marked with dots and highlighted areas with ooo's on the line drawing.

2 Ground Snow

Float the snow using the 1-inch (25mm) Phylbert, fairly wet and side loaded with Raw Linen. Begin at the top of the ground area and paint with a horizontal motion, using the front and back of the brush. Walk the color down toward the bottom area. The color should be on the top side of the brush when doing this. Allow to dry. Repeat the floats using White for highlights, again starting at the top and walking the color down to the foreground.

CAKE NOTE

*Filberts are used for this technique. They hold a lot of water and create a very soft float of color. Wet the brush and
blot very lightly on a soft paper towel. Load just one corner of the brush with paint and blend thoroughly on the palette.
Allow the paint and water to blend through the bristles by using heavy pressure on the strokes. But don't let the paint
spread to the other side of the brush. Do not twist the hairs of the brush while blending or stroking on the surface.
When the proper amount of paint has been blended, (the blended stroke is a smooth gradation of color on one side and
fades to nothing on the other side), it is ready to be placed on the surface. Use a pat-and-pull motion for this.*

*If two colors are noted for floating, simply load the first color on the side of the brush, blend on the palette, then load
the second color on the same side of the brush and blend again.*

All shading and highlighting is floated color, unless otherwise noted.

Snug as a Bug

Head

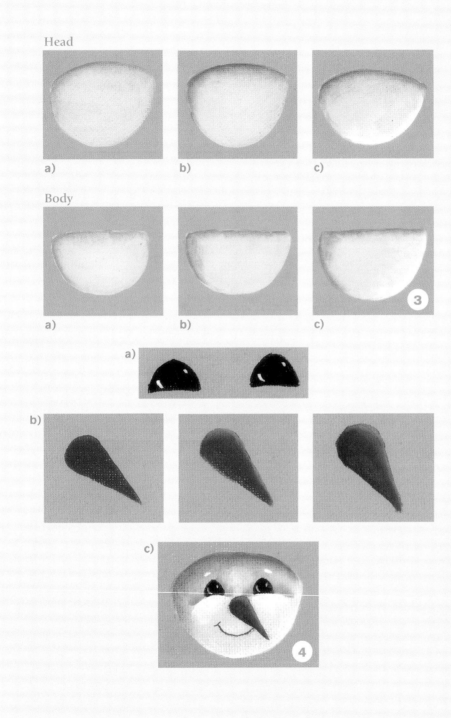

a) b) c)

Body

a) b) c)

a)

b)

c)

3 Head & Body

a) Basecoat with Raw Linen. The no. 10 filbert is used for basecoating, shading and highlighting. The first shading is done with Mudstone.

b) Repeat the shading areas with extremely transparent Spice Brown.

c) Highlight with White. Begin on the right side and walk the brush back and forth toward the center area on the body. Transfer the facial features from the line drawing onto the head. When finished, float a bit more snow in front of the body, using White with the no. 10 filbert.

4 Facial Features

a) Eyes: Use the no. 1 short liner and Dark Burnt Umber. Highlight the lower left side of each eye and also each upper right side with White on the liner tip.

b) Carrot nose: Base the nose with Georgia Clay on the no. 2 filbert. Highlight the upper edge with George Clay and Sea Grass. Shade the lower edge with Spice Brown and Dark Burnt Umber.

c) Float Mudstone above the cheeks and around the eyes on the no. 6 filbert. Repeat the shading areas with extremely transparent Spice Brown. Highlight the top of the cheeks with White on the no. 6 filbert. Apply a tiny White stroke over eyes for eyebrows. Use the no. 1 liner and Dark Burnt Umber to paint the mouth.

a)

b)

(5)

a)

b)

c)

(6)

a)

b)

(7)

c)

5 Sweater

a) Basecoat with Barn Red, using the no. 10 filbert. Shade with Chocolate Cherry.

b) Zigzag trim is made with the no. 1 liner, using Blue Storm for the first line. The second zigzag line is painted with Timberline.

6 Fur Trim

a) Side load the no. 2 filbert with Mudstone. Pat on Mudstone, keeping the tip of the brush directed to the outside edges for a furry look.

b) Highlight the fur by side loading the Mudstone side of the brush into White. Lightly pat on highlights, again keeping the edges fuzzy.

c) Repeat the highlights, using more White and keeping the lighter area toward the right and upper edges of all fur areas. Shade the shadow areas if necessary, using a transparent float of Mudstone and Spice Brown.

7 Scarf

a) Basecoat with Olive Yellow, using the no. 6 filbert. Highlight the outer edges of all areas and above the creases on the neck with Sea Grass.

b) Shade with Timberline. Use the no. 1 short liner with thinned Blue Storm for the fringe.

c) Spots are outlined with a wash mix of Blue Storm and water on the no. 1 short liner, and then painted in with this transparent mixture.

Snug as a Bug

a)

b)

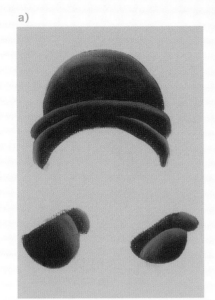

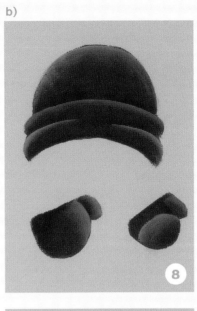

8

a)

b)

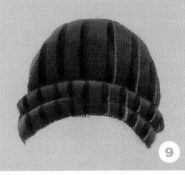

9

8 Hat & Mittens

a) Both items are basecoated with Blue Storm, using the no. 8 filbert for the hat and the no. 2 and no. 6 filberts for the gloves. The highlight is placed on the hat at the top of the crown, the top of the brim and along the top of the fold line on the hat brim with Blue Storm and Blue Wisp on the no. 8 filbert.

b) Use a mix of Blue Storm and Dark Burnt Umber to shade. Repeat the same shading and highlight colors for the mittens, using the no. 6 filbert.

9 Stripes on Hat

a) To paint the red stripes, use the chisel edge of the no. 2 filbert with the ferrule positioned in the same direction as the stripes. Paint the red stripes Barn Red. Shade the lower edge of each red stripe by side loading the brush into Chocolate Cherry. Position the paint side of the brush on the shaded edge of the stripe and move the brush vertically "up" the stripe, toward but not into the highlight area.

b) Highlight each red stripe by side loading into a bit of Tuscan Red that is fairly thin. Begin on the upper edge of each red stripe, move down toward but not into the shaded area. Notice the creases in the brim—this would constitute a "top" area of the red stripe. To paint the green stripes, use the no. 1 JS liner and Olive Yellow.

a)

b)

c)

d)

e)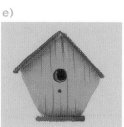

f)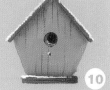

10

a)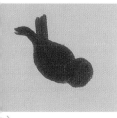

b)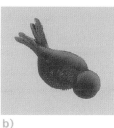

c)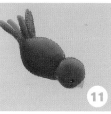

11

10 Birdhouse

a) To paint the pole, use the no. 2 filbert with Spice Brown. Shade under the platform, behind the thumb and behind the fur on the sweater with Dark Burnt Umber.

b) The house is painted Spice Tan, using the no. 6 filbert. Shade under the roof and above the platform with Spice Brown and then a touch of Dark Burnt Umber.

c) Pull thinned Spice Brown weathered lines throughout, using the no. 1 JS liner.

d) The roof and platform are Dark Burnt Umber and a touch of Mudstone, using the no. 1 JS liner.

e) Paint the hole and peg with Dark Burnt Umber, using the no. 1 short liner. Place a "C" stroke on the left side of the hole to show depth, using Dark Burnt Umber and a touch of Mudstone.

f) Paint snow on the roof, platform, hole and peg, using White on the no. 1 short liner.

11 Cardinal

a) Basecoat the entire bird, using the no. 2 filbert, with Moroccan Red.

b) Use the dirty brush and add a side load of Raw Linen. Highlight on all upper areas. Then streak over the tail to indicate feathers.

c) Shade along the bottom of the body with Chocolate Cherry. Paint the beak with Spice Tan, using the no. 1 short liner. Paint the eye with a touch of Dark Burnt Umber. Add a tiny White speck for a shine in the eye.

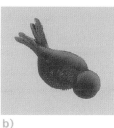

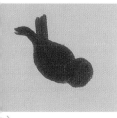

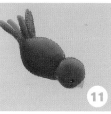

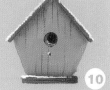

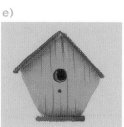

"Folk Art Snow Angel"

LYNNE DEPTULA

MEDIUM: *Acrylic*

COLORS: **DecoArt Americana:** *Admiral Blue • Baby Blue • Lamp (Ebony) Black • Black Forest Green • Bright Green • Buttermilk • Cadmium Orange • Citron Green • Graphite • Russet • Sable Brown • Sapphire • Slate Grey • Tangerine • True Red • Titanium (Snow) White • Santa Red*

BRUSHES: **Loew-Cornell:** *Series 7159 ³⁄₄-inch (10mm) flat wash • Series 7300 no. 8 flat shader • Series 7300 no. 16 flat shader • Series JS no. 2 JS liner • Series JS no. 10/0 liner*

OTHER SUPPLIES: *J.W. etc. Right Step Satin Varnish • stylus • well-worn white graphite paper*

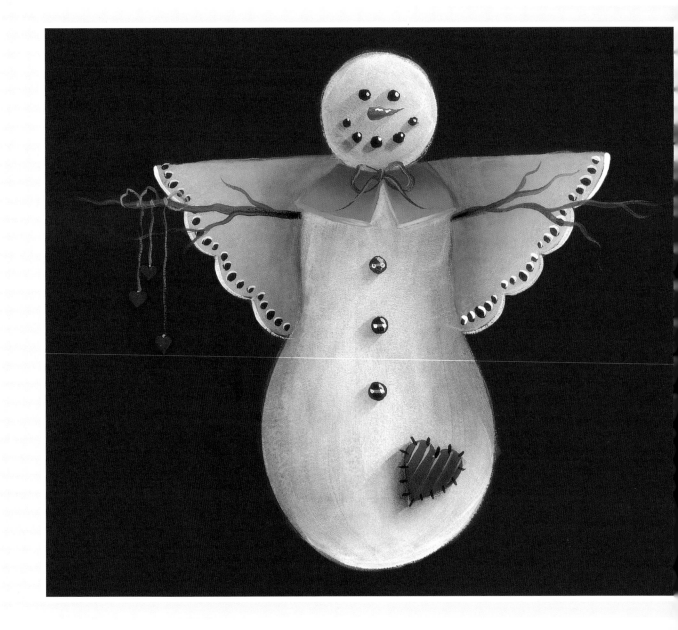

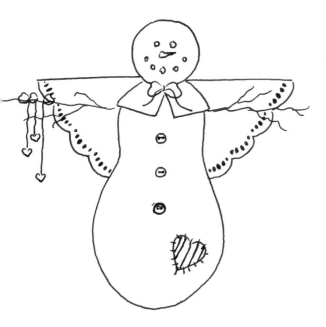

1 Line Drawing

This line drawing may be hand-traced or photocopied for personal use only. Enlarge at 156% to bring it up to full size.

2 Basecoat

Basecoat the background using the ³/₄-inch (10mm) wash and two layers of Black Forest Green. Let dry completely and sand lightly between basecoat layers. Using well-worn graphite paper and a stylus, lightly transfer the line drawing. Using the ³/₄-inch (10mm) flat, basecoat the angel body with one layer of Buttermilk. Using the no. 8 flat, basecoat the collar with two coats of Sapphire. Using a no. 16 flat, basecoat the wings with two layers of Slate Grey.

3 Shading

Using a ³/₄-inch (10mm) flat side loaded sparingly into paint, shade the wings where they tuck behind the body with a wide side-load float of Graphite. Using the same brush, shade the angel body on the left side of the head, under the collar and along the waist area on both sides of the angel body with a soft side-load float of Sable Brown. Using a no. 6 flat, shade the collar under the head with a side-load float of Admiral Blue.

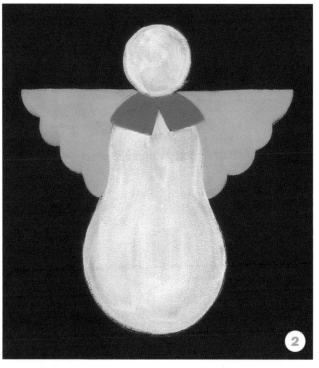

Folk Art Snow Angel

4 Highlighting

Using a no. 16 flat, highlight the scallops of the wings, right side of the angel head and around the lower right curve of the angel body with a soft side-load float of Titanium (Snow) White. Use clean water to dampen the entire angel body and then apply a flip-flop float of Titanium (Snow) White in the middle area of the angel body with a no. 16 flat. While the surface is still damp, soften the flip-flop float into the surface by gently stippling over the highlight area with a clean mop brush. Using a no. 16 flat, highlight the lower edge of the collar with a side-load float of Baby Blue.

5 Buttons, Eyes, Mouth & Heart

Using a no. 2 JS liner, paint the round buttons, coal eyes and coal mouth with Lamp (Ebony) Black. Basecoat the nose with Cadmium Orange. Basecoat the heart with two layers of True Red.

6 Shading Facial Details & Details on Wings

Using a no. 8 flat side loaded into Russet, shade the lower side of the nose and heart. Using a no. 2 JS liner, paint the descending sizes of dashes on the scallops of the wings.

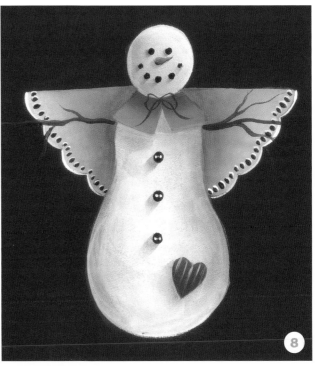

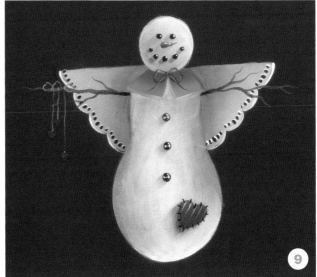

Highlights & Details

Using a no. 8 flat side loaded into Tangerine, highlight the top edge of the nose. With a no. 10/0 liner, detail the heart and paint the threads on the buttons with Bright Green. Highlight the top edge of each line on the heart with a top line of Citron Green. Outline the top curve of each "hole" in the wing and along the scalloped edge of the wing with Titanium (Snow) White.

Twig Arms & Additional Shading

With a no. 2 JS liner, paint the thin twig arms with thinned Russet. Highlight, if needed to show up on the dark background, with top lines of Sable Brown. Paint a line of Bright Green along the lower edge of the collar. Paint the button holes with very small dots of Titanium (Snow) White.

Set the buttons, heart and facial features by shading next to the left lower side of each element with a side-load float of Graphite. Reinforce the shading on the wings next to the body with a side-load float of Graphite on a ³/₄-inch (10mm) flat. Using the no. 10/0 liner and thinned True Red, paint the line work down at the neck of the snow angel.

Final Details

Highlight, with the no. 10/0 liner, the top right curve of each button and facial feature with a short curved line and/or dot of Titanium (Snow) White. Using the same brush and thinned paint, "tie on" Santa Red hearts with lines of Sapphire. Highlight the loops and "hit and miss" on the length of the ties with thin top lines of Baby Blue. Stitch the heart with short lines of Lamp (Ebony) Black. Highlight the line work bow at the neck with thin top lines of Cadmium Orange.

To finish, erase any visible graphite lines. Varnish with two or three coats of J.W. etc. Right Step Satin Varnish. Cure for 24 hours between layers of varnish.

"Mr. Red's Bed & Breakfast"

PHYLLIS TILFORD

MEDIUM: *Acrylic*

COLORS: **Delta Ceramcoat:** *Barn Red • Black • Black Green • Dark Burnt Umber • Dark Forest Green • Hammered Iron • Moroccan Red • Mudstone • Sandstone • Spice Brown • Spice Tan • Straw • Terra Cotta • Wedgwood Green • White*

BRUSHES: **Loew-Cornell:** *Series 3500 no. 2 filbert • Series 3500 no. 6 filbert • Series 3500 no. 8 filbert • Series 3500 no. 10 filbert • Jackie Shaw Series no. 1 JS liner • Series 7350 no. 1 liner • Series 2014 no. 4 scumbler • sponge brush •* **Tilford:** *1-inch (25mm) Phylbert*

OTHER SUPPLIES: *J.W. etc. Extender • old, soft toothbrush*

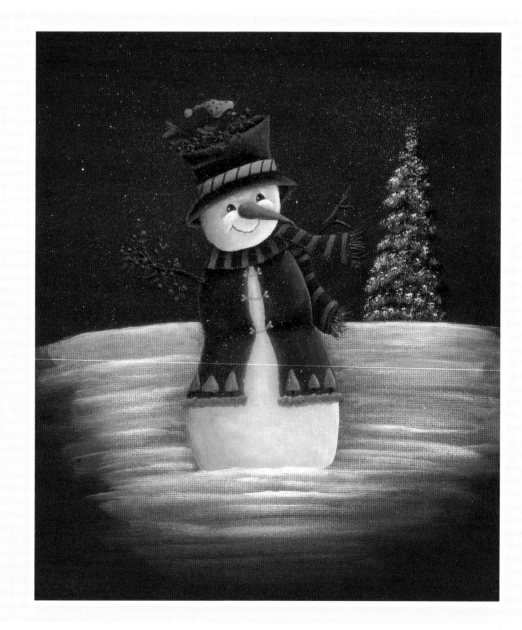

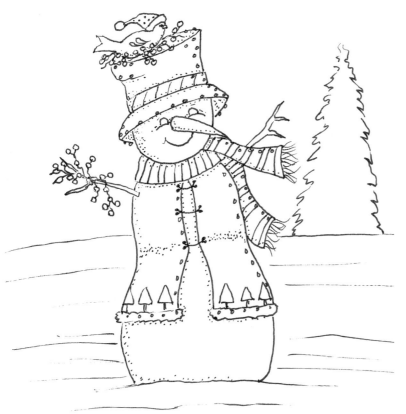

1 Line Drawing

This line drawing may be hand-traced or photocopied for personal use only. Enlarge at 167% to bring it up to full size. Shaded areas are marked with dots and highlighted areas with ooo's on the line drawing.

2 Ground Snow

Float on the snow using a fairly wet 1-inch (25mm) Phylbert, side loaded with Sandstone. Begin at the top of the ground area and paint with a horizontal motion. Use the front and back of the brush, walking the color down toward the bottom area. The color should be on the top side of the brush when doing this. Allow to dry. Repeat the floats, using White for highlight. Again, start at the top and walk the color down to the foreground.

ʌKE NOTE

⸺lberts are used for this technique. They hold a lot of water and create a very soft float of color. Wet the brush and blot
⸺ry lightly on a soft paper towel. Load just one corner of the brush with paint and blend thoroughly on the palette. Allow
⸺e paint and water to blend through the bristles by using heavy pressure on the strokes. But don't let the paint spread to
⸺e other side of the brush. Do not twist the hairs of the brush while blending or stroking on the surface. When the proper
⸺nount of paint has been blended, (the blended stroke is a smooth gradation of color on one side and fades to nothing on
⸺e other side), it is ready to be placed on the surface. Use a pat-and-pull motion for this.

If two colors are noted for floating, simply load the first color on the side of the brush, blend on the palette, then load
⸺e second color on the same side of the brush and blend again.

All shading and highlighting is floated color, unless otherwise noted.

Mr. Red's Bed & Breakfast

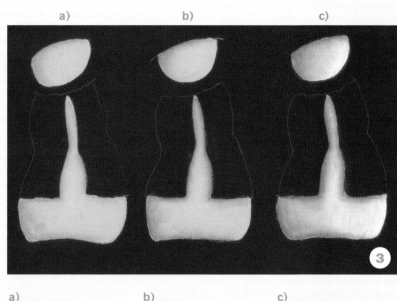

a) b) c)

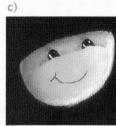

a) b) c)

d) e) f)

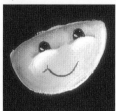

g)

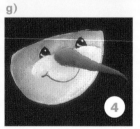

3 Head & Body

a) Basecoat with Sandstone. The no. 10 filbert is used for basecoating, shading and highlighting. The first shading is Mudstone.

b) Repeat the shading areas with transparent Hammered Iron and Spice Brown.

c) Highlight with White. Begin on the right side and walk the brush back and forth toward the center area on the face and body.

4 Facial Features

a) To paint the eyes and mouth, use the no. 1 short liner and paint Dark Burnt Umber.

b) Add a highlight on each eye in the lower left side and a smaller highlight on each upper right side with White on the tip of the liner.

c) Float Mudstone above the cheeks and around the eyes, using the no. 6 filbert. Repeat the shading areas with transparent Hammered Iron and Spice Brown.

d) Use the no. 6 filbert to highlight the top of the cheeks and the forehead with White.

e) To paint the carrot nose, basecoat with Terra Cotta on the no. 2 filbert.

f) Highlight the upper edge of the carrot with Terra Cotta and Straw.

g) Shade the lower edge with Spice Brown.

a)

b)

)

)

d)

a)

b)

)

d)

)

f)

5 Coat

a) Basecoat with Dark Forest Green on a no. 8 filbert. Highlight with Dark Forest Green and Sandstone.

b) Shade with Black Green.

c) Paint the little trees with a wash of Wedgwood Green, well blended with water, on the short liner brush. Use the same dirty brush and a side load of Sandstone for a transparent highlight. Paint the trunks with Spice Brown and a touch of Dark Burnt Umber, using the short liner.

d) Fur is patted on with the no. 2 filbert. Pat on Dark Forest Green; then use the dirty brush to pat on Spice Tan. Add final highlights with the dirty brush and Sandstone.

e) The clasps are painted with the short liner and Spice Tan. While still wet, use the same dirty brush and add a touch of Straw to the tip and highlight the curved outer edge of each heart.

6 Scarf

a) Paint the scarf Barn Red, using the no. 2 filbert. Highlight with Barn Red and Terra Cotta.

b) Shade with Barn Red and Dark Burnt Umber.

c) Paint the stripes with a wash mix of Terra Cotta, using the no. 1 short liner. Highlight with Terra Cotta and Straw.

d) Shade with Barn Red.

e) The fringe is made with the no. 1 JS liner and Barn Red.

f) Over stroke with the dirty brush and Terra Cotta.

Mr. Red's Bed & Breakfast

7 Twig Arms

a) Basecoat with Dark Burnt Umber and a touch of Sandstone.

b) Highlight while the surface is still wet. With the same dirty brush add a bit more Sandstone. Apply on all upper areas.

8 Berries & Vines

a) Paint all vines with thinned Dark Burnt Umber and Sandstone on a JS liner.

b) Berries are basecoated Moroccan Red, using the short liner.

c) Highlight the upper tip of each berry with a mix of Moroccan Red and Straw.

9 Hat & Hatband

a) Basecoat the entire hat with Black Green, using the no. 2 and no. 8 filberts. Highlight while the surface is still moist with the dirty brush and with floats of Sandstone.

b) Shade with Black. Basecoat the hatband with Spice Tan.

c) Shade on the left side and above the brim with Spice Brown and a touch of Dark Burnt Umber.

d) Highlight on the upper right edge with Spice Tan and Straw.

e) Paint the stripes with Barn Red on the short liner.

a)

b)

c)

d)

e)

10 Cardinal

a) Paint the bird Moroccan Red with the no. 2 filbert. On the final coat, use the dirty brush, side loaded into a touch of Sandstone, and highlight the tip of the tail, the cheek and apply two comma strokes for the wings.

b) Shade along the bottom of the body with Dark Burnt Umber.

c) Paint the beak with Spice Tan on the short liner. Paint the eye with a dot of Dark Burnt Umber on the tip of the short liner.

d) Add a tiny White highlight dot to the eye. The stocking cap is Wedgwood Green on the no. 2 filbert. Shade the lower edge of the cap with Dark Forest Green. Apply dots with the same color, using a stylus. Pat on the fur brim and tassel with the no. 2 filbert and Spice Tan.

e) Highlight the upper edge of the fur with Spice Tan and Straw. Shade the lower edge with Spice Brown.

11 Evergreen Tree

a) Wet the no. 4 scumbler; blot heavily. Flatten the brush on the palette to get a good edge on the chisel. Load the brush with paint on the top of the brush tip. Begin with color at the tree top and paint in a downward direction. Start at the tree top and pat downward with Black Green.

b) Pick up a bit of White on the top of the dirty brush tip and highlight. Begin at the tree top.

c) Reinforce highlights on the left side with more White on the same dirty brush.

TAKE NOTE

pply a smooth coat of extender on the ground area with the sponge rush. Brush again if any puddles exist. Side load the no. 10 filbert into Vhite, blend lightly and apply for more highlights. The extender gives nger open blending time. Leave some shadows in the area. Don't verwork the area as it dries. Let dry, apply more extender and continue ntil the desired highlights are achieved. Let dry. Spatter lightly with Vhite, using an old, soft toothbrush.

CHAPTER **3**

Painting Santas & Snowmen

In this chapter, we combine Santas with snowmen. You can paint them together in the projects in this chapter or use your imagination and combine Santas with snowmen from the previous chapters. Just make sure to relax, enjoy and let your creativity flow free!

"Pen & Ink Santa & Snowman"

BARBARA NIELSEN

MEDIUM: *Acrylic, pen & ink*

COLORS: **Delta Ceramcoat:** *Ocean Reef Blue • Pumpkin • Christmas Green • Black • Mendocino Red • White • Burnt Umber • Yellow • Golden Brown • Fleshtone • Midnight Blue • Liberty Blue • Burnt Sienna •* **DecoArt Americana paints:** *Cadmium Red*

BRUSHES: **Loew-Cornell:** *Series 7000 no. 3 round • Series 7000 no. 5 round • Series 7300 no. 10 flat • Series 7350 no. 0 liner • Series 7400 ¼-inch (6mm) angular shader • Series 7400 ½-inch (13mm) angular shader • small, old scruffy brush*

OTHER SUPPLIES: *Rotring Rapidoliner pen no. .25*

2

Ink Drawing

Ise a Rotring Rapidoliner pen no. .25 to ink the drawing.

2 Wash Basecoats

Wash the sky with Ocean Reef Blue. Wash Santa's face with Fleshtone. Use Cadmium Red to wash Santa's hat, coat, cheeks, mouth, snowman's cheeks, hat trim and hearts. With Liberty Blue, wash Santa's scarf and glove. Use Golden Brown to wash the scarf fringe. Wash the leaves with Christmas Green. Use the above colors for patchwork on the scarf. Wash the carrot with Pumpkin. Wash the twig with Burnt Umber. The boot is washed with Black.

Pen & Ink Santa & Snowman

3

4

3 Float Shading

Use Golden Brown to shade the hat and coat fur, the snowman and the ground. Shade the blue scarf, glove and patchwork areas as a whole with Midnight Blue. Add a second shade with the same color to the hat and coat fur, snowman and ground. Use Mendocino Red to shade all red areas. Shade the twig with Burnt Umber. Shade Santa's face, scarf fringe and the carrot nose with Burnt Sienna. Use Black to shade Santa's beard, mustache and boot.

4 Finishing Details

Deepen shadows with Midnight Blue. Add warm highlights with Yellow. Use White to pounce snow, highlight eyes and apply small strokes over the beard and mustache. Apply tints dots and re-ink, where necessary.

"The Snowman's Christmas Visitor"

PRUDY VANNIER

MEDIUM: *Acrylic*

COLORS: ***DecoArt Americana:*** *Alizarin Crimson • Black Plum • Antique Gold • Buttermilk • Lamp (Ebony) Black • Hot Shots Fiery Red • Driftwood • Burnt Umber • Marigold • Citron Green • Moon Yellow • Country Red • Terra Cotta • Deep Burgundy • Winter Blue • Deep Midnight Blue • Black Green • DeLane's Cheek Color • Dioxazine Purple • Festive Green • Light Buttermilk • Medium Flesh • Milk Chocolate • Neutral Grey • Plantation Pine • Tangelo Orange • Titanium (Snow) White*

BRUSHES: *¾-inch (10mm) flat • no. 2 flat • Prudy's Best Floater • Prudy's Best Pouncer • Prudy's Best Liner*

OTHER SUPPLIES: *spattering tool • white graphite paper*

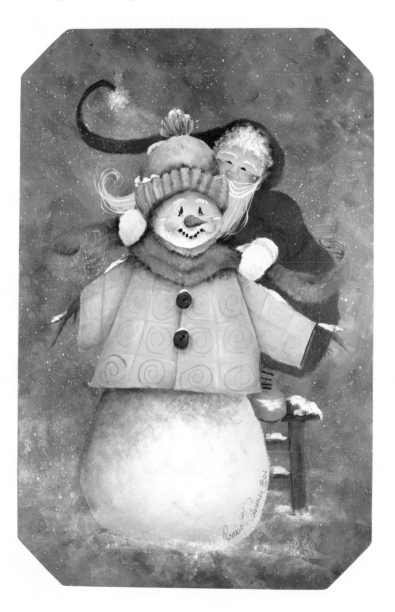

The Snowman's Christmas Visitor

1 Line Drawing

This line drawing may be hand-traced or photocopied for personal use only. Enlarge at 114% to bring it up to full size.

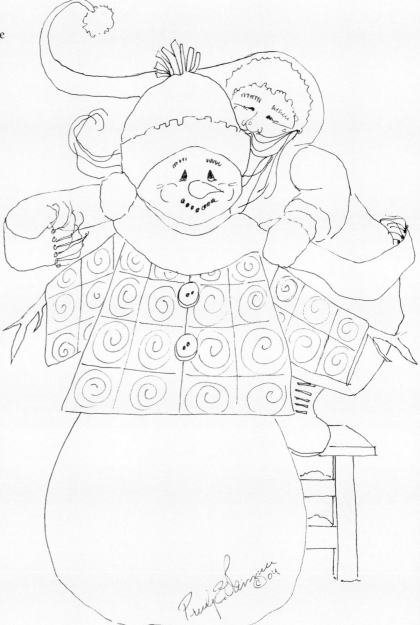

TAKE NOTE

On your palette have puddles of Titanium (Snow) White and Deep Midnight Blue. Using the ³/₄-inch (10mm) flat, slip-slap both colors for a mottled, stormy effect. Spatter heavily with thinned Titanium (Snow) White, using your spattering tool. Transfer the line drawing with graphite paper, but do not transfer the face or coat detail.

Painting Santa's Face

2 Santa's Face

a) Basecoat Santa's face with Medium Flesh. Base his hat with Country Red. The beard and mustache are Driftwood. Use Prudy's Best Floater to float Terra Cotta on the face next to the fur area, under the eyebrows and down both sides of the nose.

b) Add cheeks and eyes. Float DeLane's Cheek Color on the outer edges of the cheeks and the end of the nose. Deepen slightly with another float of Country Red. The eyes are Lamp (Ebony) Black painted with the Best Liner. Pounce Burnt Umber fur.

c) The eyebrows are strokes of Titanium (Snow) White. Eyelashes and highlights on the nose and cheeks are also Titanium (Snow) White. Add Light Buttermilk to the fur area. Add facial, beard and mustache detail with Titanium (Snow) White.

Painting Snowman's Face

a)

3 Snowman's Face

a) Basecoat the face with Winter Blue. Side load Prudy's Best Floater with Deep Midnight Blue and float under the face, under the hat, on the left side of the face and under the nose and cheeks.

b) Add more shading with Dioxazine Purple. Fill the carrot nose in with Tangelo Orange.

c) Float Tangelo Orange across the bottom of the cheeks and walk up the color. Float Alizarin Crimson across the bottom of the nose. Add Titanium (Snow) White highlights.

d) Eyebrows and cheek highlights are strokes of Titanium (Snow) White. Eyes and mouth are Lamp (Ebony) Black. Use the Best Liner to make crevices and cracks in the carrot nose. Strengthen the Titanium (Snow) White details.

b)

c)

d)

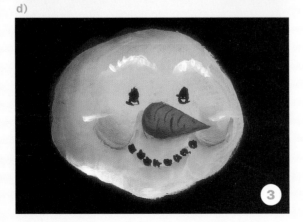

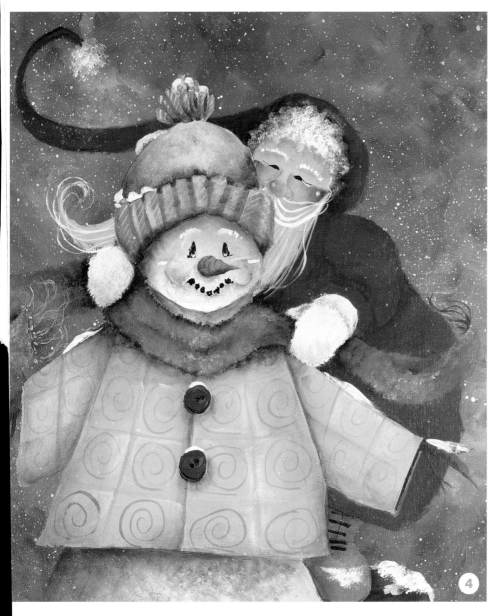

4 Santa's Body

Basecoat the coat with Country Red. Float Black Plum on the hat next to the fur and across the bottom of the hat tail with Prudy's Best Floater. Also float the same color around the beard and arm, next to the snowman and at the bend in the arm. Side load the Best Floater with Fiery Red. Pat-blend this in the non-shaded areas of the hat and coat. Use the Best Pouncer to pounce Burnt Umber in the fur areas. While wet, side load the Pouncer in Light Buttermilk. Lightly pat this in the center of the fur area above the face, blending into the Burnt Umber at the sides of the fur area. Also pounce the pom-pom.

The boots are painted Neutral Grey. Shade the boot at the top and next to the snowman with floats of Black Green. Line the sole and laces with Lamp (Ebony) Black.

Pounce the mittens with Buttermilk. While wet, pounce Terra Cotta to shade on the thumb, at the bottom of the hand area and at the wrist.

Painting Snowman's Body

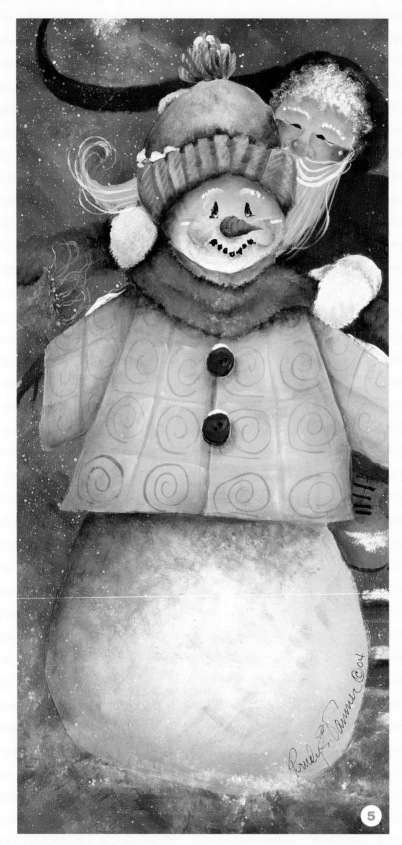

5 Snowman's Body

The snowman's face and body are based with Winter Blue. Use Prudy's Best Pouncer to shade the bottom of the snowman. This goes under the coat and at the left. Highlight by pouncing Titanium (Snow) White in the center-right of the body, across the chin and on the cheeks.

Double load the no. 2 flat with Milk Chocolate on top and Burnt Umber on the bottom to paint the arms.

Basecoat the hat crown and coat with Marigold. Float Milk Chocolate lightly down the sides of the coat, down the center to make the opening, on the sleeves where they attach to the coat and under the scarf. Deepen slightly with Burnt Umber. Lightly float Milk Chocolate to make vague square patterns on the coat. In each square paint a swirl using the Best Liner and thinned Alizarin Crimson. Highlight along the "seams" of each square with floats of Moon Yellow (refer to the picture for placement.)

The buttons are Deep Burgundy with Burnt Umber edges and Lamp (Ebony) Black holes. Shade around the bottoms of them with a float of Burnt Umber.

The hat brim and yarn top are Antique Gold. The yarn pom-pom and the ribbing around the hat are shaded with Burnt Umber by floating stripes between the ribs and at the base of each string on the pom-pom. Highlight with light floats of Moon Yellow, then line diagonally with the same. The crown of the hat is pat-blended with Prudy's Best Pouncer to make it look slightly fuzzy. Place Moon Yellow in the center area to highlight and Burnt Umber across the top of the ribbing and at the sides. Pounce a little Tangelo Orange at the sides.

The scarf is Festive Green pounced on with Prudy's Best Pouncer. Shade by lightly pouncing Plantation Pine under the chin area, in the folds and by the hands. Deepen a little with Black Green. Highlight with Citron Green on the outside edges of the folds (refer to the picture for placement.) Use Prudy's Best Liner to paint the fringe with Citron Green and Black Green. Make sure the fringe curves. Also use the Best Liner to paint the knots at the top of the fringe with the same.

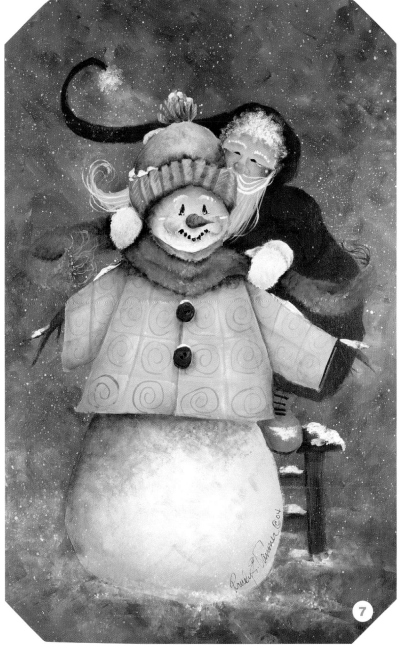

6 Ladder

Basecoat the ladder with Milk Chocolate. Use Burnt Umber to paint the edge of the top of the ladder and to shade where the rungs attach to the legs. Use the Best Liner to add some wood grain to the ladder.

7 Finishing Details

Use Titanium (Snow) White to slip-slap snow across the base of the snowman. Add snow to the ladder, Santa's boot, on the hat and shoulders of the snowman, over the buttons and anywhere you think snow would settle on a snowy night.

Varnish with your favorite water-based varnish in either satin or matte finish.

About the Artists

TRUDY BEARD

Trudy Beard is an internationally known teacher and a Certified Decorative Artist living in Rockford, Illinois. She travel teaches all over the United States and Canada. She's the author of more than a dozen books.

LYNNE DEPTULA

Lynne Deptula resides in Grand Rapids, Michigan. She and Judy Diephouse have been business partners for more than 15 years, designing and teaching decorative painting. Lynne teaches at decorative painting conventions and travel teaches at seminars throughout the United States.

JUDY DIEPHOUSE

Judy Diephouse lives in Rockford, Michigan. She travels throughout the United States and Canada, teaching at conventions and seminars. She and her business partner, Lynne Deptula, own Distinctive Brushstrokes and Publishing. They have published over 150 pattern packets and 20 books. They have just finished their fourth book with North Light.

PAM GRADY

Pam Grady is from Fallon, Missouri. She has published four books and more than seventy-five pattern packets. Her two painting loves are folk art and Americana pieces.

PEGGY JESSEE

Peggy Jessee lives in Cincinnati, Ohio. She started painting in the late 1970s, after taking a five day seminar from Priscilla Hauser. Painting has been part of her life ever since. She loves to teach. Peggy primarily teaches in her home studio and at the Heart of Ohio Tole Convention.

DELANE LANGE

DeLane Lange lives in St. Louis, Missouri. She loves to paint flowers, children and Santa! She was educated at the Kansas City Art Institute and has designed for Hallmark Cards, Russell Stover Candy and the Lily Tulip Co. She has taught decorative painting at national conventions and around the world. She is also the author of many books.

CAROL MAYS

Carol Mays is a decorative painter, designer, teacher and business woman. She is the author of nine books. Carols has also created numerous pattern packets on both decorative and glass painting. You will find her at most of the decorative painting conventions around the country.

JUDY MORGAN

Judy Morgan is a popular painter and designer who owns her own business called Apple Cheeks Publications. She has designed over ninety pattern packets, has self-published two project books and has been published in various painter's magazines. She teaches classes and seminars from coast to coast.

BARBARA NIELSEN

Barbara Nielsen started painting with oils and later switched to acrylics. By combining acrylics with pen and ink, she can achieve the detail that she loves. She has been teaching this technique for many years. Barbara has authored three books and a line a pattern packets.

MARY ANN SPAINHOUR

Mary Ann Spainhour teaches at the Society of Decorative Painters and Heart of Ohio Tole conventions. She served as President of the Society of Decorative Painters from 1998 through 1999. She also teaches in her shop, "Brush Strokes", located in Pinnacle, North Carolina.

PHYLLIS TILFORD

Phyllis Tilford has designed over five hundred pattern packets, authored seven books and contributed to numerous decorative painting magazines. She has been travel teaching throughout the country and abroad for over 20 years. Phyllis and her husband operate The Tole Mill in Melbourne, Florida.

KERRY TROUT

Kerry is a self-taught artist who has been painting since she was a child. She is the author of three North Light books, is

a DecoArt Helping Artist and sells her projects on CD-ROM. Kerry developed Liquid Shadow, a water-based medium that enables painters to easily paint cast shadows and deepen shading. Kerry lives in Danville, Indiana.

PRUDY VANNIER

Prudy Vannier discovered decorative painting in 1983. By 1985 she was teaching and publishing pattern packets and books. Prudy is the Past President of The Society of Decorative Painters. During her many years of affiliation with the Society, she served as chair of the Business Committee and Public Relations Committee. Her projects have been published in many painting magazines and books. Prudy lives in Northville, Michigan.

PAT WAKEFIELD

Pat Wakefield is the author of twenty-eight books and thirty-nine painting packets. She has taught classes for 32 years at Cambridge House in Kansas City. She has also travel taught in much of the United States and Canada. Pat has served as a judge in the certification program for the Society of Decorative Painters. She is versatile in the use of tube oils, acrylics, watercolors and pastels.

JEAN ZAWICKI

Jean Zawicki's interest in decorative painting began in the late 1960s. Since then, she has travel taught extensively throughout the United States and Canada, as well as teaching in her own home. Her thirtieth book is in the process of being published and she has designed many pattern packets and been published in various trade magazines. She resides in St. Cloud, Florida.

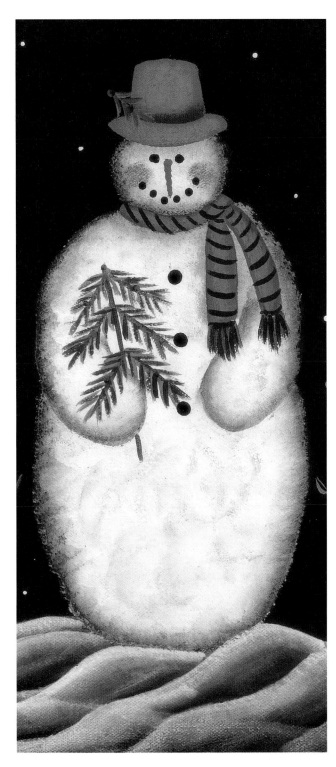

Resources

PAINTS

DecoArt Americana
DecoArt
P.O. Box 327
Stanford, KY 40484
(606) 365-3193
www.decoart.com

Delta Ceramcoat
Delta Technical Coatings, Inc.
2550 Pellissier Place
Whittier, CA 90601
(800) 423-4135
www.deltacrafts.com

FolkArt
Plaid Enterprises, Inc.
P.O. Box 7600
Norcross, GA 30091-7600
(800) 842-4197
www.plaidonline.com

BRUSHES

Bette Bird Brushes
P.O. Box 2526
Duluth, GA 30136
(770) 623-6097

Loew-Cornell
563 Chestnut Ave.
Teaneck, NJ 07666
(201) 836-7070
www.loew-cornell.com

Royal & Langnickel Brush Mfg.
6707 Broadway
Merrillville, IN 46410

Phyllis Tilford brushes
The Tole Mill
617 Sheridan Woods Drive
W. Melbourne, FL 32904
www.tolemill.com

Prudy's Studio
279 Maplewood Street
Northville, MI 48167-1149
www.prudysstudio.com

Schraff Brushes, Inc.
P.O. Box 746
Fayetteville, GA 30214
(888) 724-2733
www.artbrush.com

OTHER SUPPLIES

Rotring Rapidoliner
Available at art supply stores

J. W. Etc.
2205 First Street, Suite 103
Simi Valley, CA 93065
(805) 526-5066
www.jwetc.com

CANADIAN RETAILERS

Crafts Canada
(877) 55CRAFT
www.craftscanada.ca

Folk Art Enterprises
P.O. Box 1088
Ridgetown, ON, N0P 2C0
(800) 265-9434
www.folkartenterprises.com

MacPherson Craft Wholesale
91 Queen St. E.
P.O. Box 1810
St. Marys, ON, N4X 1C2
(800) 238-6663
www.macphersoncrafts.com

Maureen McNaughton Ent., Inc.
RR #2
Belwood, ON, N0B 1J0
(519) 843-5648
www.maureenmcnaughton.com

Mercury Art & Craft Supershop
332 Wellington St.
London, ON, N6C 4P7
(519) 434-1636

Town & Country Folk Art Supplies
93 Green Lane
Thornhill, ON, L3T 6K6
(905) 882-0199

UK RETAILERS

Art Express
Design House
Sizers Court
Yeadon LS19 6DP
0800 731 4185
www.artexpress.co.uk

Atlantis European Ltd.
7–9 Plumber's Row
London E1 1EQ
020 7377 8855
www.atlantisart.co.uk

Crafts World (head office)
No. 8 North Street
Guildford
Surrey GU1 4 AF
0700 757070

Green & Stone
259 Kings Road
London SW3 5EL
020 7352 0837

Hobby Crafts (head office)
River Court
Southern Sector
Bournemouth International Airport
Christchurch
Dorset BH23 6SE
0800 272387

Homecrafts Direct
PO Box 38
Leicester LE1 9BU
0116 2697733
www.homecrafts.co.uk

Index

North Light Books!

A great book of both instruction and inspiration in one go-to reference! With 40 step-by-step lessons from favorite decorative painters and landscape artists, this book covers a variety of evergreens, shrubs, leaves, deciduous trees, grasses and distant foliage. There are no difficult techniques to master, no boring theory and no heavy-duty instruction. Just pure, put-it-to-work directions with lots of pictures and short, clear captions.

ISBN 1-58180-613-2, paperback, 128 pages, #33183-K

With 12 step-by-step projects for all skill levels, acrylic enthusiasts will be able to paint popular flowers for each season, including spring lilacs, summer roses, fall asters and winter narcissus. Contains traceable patterns, color charts and material lists for each project.

ISBN 1-58180-602-7, paperback, 128 pages, #33160-K

Devoted Donna Dewberry fans and beginning painters alike will learn to create 50 different flowers. Using Donna's innovative and easy-to-use method, you'll learn the basic one-stroke technique, plus you'll get tips on painting petals, leaves, vines, foliage and filler flowers. Also included is a section on how to create beautiful floral compositions.

ISBN 1-58180-484-9, paperback, 144 pages, #32803-K

Turn plain, inexpensive glassware into holiday treasures with over 16 projects to fill your home and loved ones' hearts with joy. A magical blend of elegance and whimsy, this collection features snowmen, holly, candy canes, gingerbread "kids" and more. Includes a cookie plate for Santa, porcelain ornaments painted with country snowscapes, etched wine glasses and a breathtaking set of Christmas rose tableware.

ISBN 1-58180-364-8, paperback, 128 pages, #32378-K

These and other fine North Light books are available at your local art & craft retailer, bookstore, online supplier or by calling 1-800-448-0915.